ANGLESEY
TOWNS & VILLAGES

GERAINT JONES &
GWENLLIAN JONES ROWLINSON

AMBERLEY

First published 2015

Amberley Publishing
The Hill, Stroud
Gloucestershire, GL5 4EP

www.amberley-books.com

British Library Cataloguing in Publication Data.
A catalogue record for this book is available from the British Library.

ISBN 978 1 4456 5152 1 (print)
ISBN 978 1 4456 5153 8 (ebook)

Typesetting and Origination by Amberley Publishing.
Printed in Great Britain.

INTRODUCTION

Anglesey, which lies off the coast of north-west Wales, is among the larger offshore islands of the British Isles. Its area is approximately 275 square miles (704 square kilometres). There are five towns in Anglesey (Amlwch, Beaumaris, Holyhead, Llangefni and Menai Bridge) and Llangefni is the administrative centre. The rest of the island is made up of villages and scattered rural communities, each having its own unique personality. The English name Anglesey is of Norse origin, whereas the Welsh name, Môn, is related to the Latin name, Mona.

Anglesey has been occupied for thousands of years. Ancient peoples erected standing stones (meini hirion) and megalithic tombs (cromlechi) at various times in the distant past. These sites, such as Barclodiad y Gawres (near Rhosneigr) and Bryn Celli Ddu (near Llanddaniel-fab), may have had some religious significance.

The Celts came to Britain around 500 BC and the artefacts found at Llyn Cerrig Bach in the 1940s are evidence of their use of iron. The Romans came to Anglesey in AD 60 and the Druid religion came to a violent end when Suetonius Paulinus attacked the island with thousands of men. The Romans remained in Anglesey until around AD 410 and they had established a small fort at Holyhead during this time.

After the departure of the Romans came a period which is often called the 'Age of Saints'. In the sixth century Saint Cybi and Saint Seiriol established monasteries in Holyhead and Penmon respectively, but there were many other saints who are still commemorated in the many 'Llan' place names on the island.

Viking raids became frequent from the ninth century onwards. Monasteries were targeted and the Royal Palace at Aberffraw was attacked in 968 BC. These Viking raids had ended by the twelfth century, but names of Norse origin, such as Priestholm and Skerries, still remain.

The twelfth century saw the beginning of a more settled period. The clearance of forests allowed the fertile, comparatively flat land of Anglesey to be cultivated. So productive were the lands of Anglesey that the island was described as 'Môn, mam Cymru' (Anglesey, the mother of Wales) because the island could supply the rest of Wales with grain.

By the middle of the eighteenth century, Anglesey's population had risen to about 27,000. Educational establishments in Anglesey were very few before the eighteenth century. A notable exception, of course, was the David Hughes Grammar School at Beaumaris which was established in 1603. Elementary schools began to appear in the eighteenth century. For example, Dean John Jones (1650–1727), of Plas Gwyn mansion at Pentraeth established a number of charitable schools in five parishes between 1716 and 1719. The Circulating Schools of Griffith Jones made a

significant contribution to literacy between 1746 and 1777. The only subject they taught was reading which was taught through the medium of Welsh. When these schools stopped, the Methodists saw their opportunity to make a contribution and promote Methodism at the same time. National Schools (organised by the National Society and promoting the doctrines of the Anglican Church) and later British schools (which were more acceptable to the Nonconformists) were established in the nineteenth century. National schools were established in all five of Anglesey's towns; a British school was established in all except Beaumaris. Many villages also saw the establishment of National and British Schools. There were also a multitude of private schools in the nineteenth century, especially in the towns, although many of them were short-lived. During the first half of the nineteenth century the population of Anglesey rose from 33,800 in 1801 to 57,300 by 1851.

Travellers to and from Anglesey had always relied on ferries to take them between the island and the mainland. There were a total of six ferries: Moel-y-Don, Abermenai, Tal-y-Foel, Beaumaris, Porthaethwy and Garth. Following the absorption of Ireland into the Union in 1801, it became vital to establish a convenient and rapid link between London and Dublin. The building of the two bridges over the Menai Straits, together with the railways, achieved this and also ushered a new age for Anglesey. The five towns of Anglesey, with the exception of Beaumaris, were all served by a railway station, although Menai Bridge station was somewhat unusual as it was situated on the mainland. Although a few of the island's villages had railway stations, most of the villages were insufficiently close for the railway to have a direct impact. When the Anglesey Central Railway (Gaerwen to Amlwch) closed in the 1960s, it came as a blow to a number of communities where bus services were not as frequent as those in other parts of Anglesey.

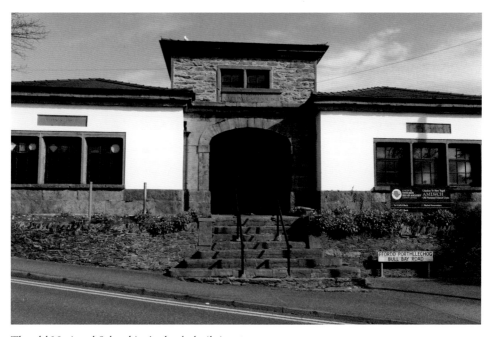

The old National School in Amlwch, built in 1821.

The development of small shops and industries all contributed to the rise of the middle class in the nineteenth century. As a consequence, there was a greater demand for education and a plethora of schools, some of them private establishments providing an English education, sprang up in all Anglesey's towns. It was also the time when banks appeared in Anglesey's towns. The Anglesey Savings Bank was established in Beaumaris in November 1818; it soon had branches in Llangefni, Holyhead and Amlwch.

Religion and the success of the Nonconformist denominations in the nineteenth century was one of the factors that defined Welsh society for years and its legacy is still with us now, even though the chapels and churches have less influence than they once had. The Nonconformists enjoyed far greater success in Wales than they did in England and were instrumental in pursuing social values such as diligence and temperance. The Sabbath was taken very seriously and partaking of certain activities (such as playing football) was considered quite inappropriate.

In 1870 the Forster Education Act established School Boards in each area. The School Boards could establish their own schools or make grants to the National or British schools. School attendance was made compulsory for children aged 5–13. Towards the end of the nineteenth century, the Welsh Intermediate Education Act of 1889 gave rise to a system of secondary education. State secondary schools (the 'county schools') had been established in Beaumaris, Llangefni and Holyhead by the turn of the century. Secondary education in Amlwch began in 1940. In 1902 the Balfour Education Act established Local Education Authorities; 'Board' schools became known as 'Council' schools.

At the beginning of the twentieth century, life in Anglesey was still fairly primitive. There was no electricity, and water was largely drawn from rivers, springs and wells.

Capel Cildwrn, Llangefni, one of the first Nonconformist chapels in Anglesey, dates from 1782.

Although some of Anglesey's towns had an electricity supply before the First World War, most people were still dependent on candles and paraffin lamps at the beginning of the 1930s. Just before the Second World War, the village communities of Cemaes, Moelfre, Benllech, Pentraeth, Trearddur and Rhosneigr were brought into the electricity network. However, the majority of the island's villages would have to wait until after the Second World War, in some cases until the 1960s, to receive an electricity supply. It was not until the 1960s that every rural community had a supply of piped water.

The First World War resulted in massive loss of life; about 1,000 Anglesey people died in the conflict. In 1921 the population of Anglesey was 51,744. In the 1920s and 1930s times were difficult for Anglesey with high unemployment; many people left the island to seek work elsewhere. Consequently, the population fell to 49,029 by 1931 and a further decline took place during the rest of the 1930s. Some improvements were made in the period between the wars, such as the provision of water, electricity and council homes. However, these were not great changes. The Second World War caused further turmoil with air bases being established and evacuees coming to Anglesey in large numbers.

Although there have been a number of industries in Anglesey over the centuries, such as quarrying, coal mining, copper mining, wool production and shoe production, the one industry which has survived and on which Anglesey still remains highly dependent is agriculture.

The post-war period was a time of profound change. New industries were being sought in order to provide jobs. The Wylfa Nuclear Power Station, the largest single project, was started in the 1960s and completed in the early 1970s. It provided construction jobs and permanent work, but the island was scarred by unsightly pylons. This industrialisation has met with only limited success. New factories can be drawn to the island with the right incentives but not all these new ventures survive. In the 2011 Census, the population of Anglesey was recorded as 69,700.

What should be remembered is that each of Anglesey's towns and villages developed in a different way. Beaumaris has a long history and has a number of historic buildings; it developed as a residential area and a holiday resort, but was comparatively untouched by industry. Amlwch, on the other hand, became the Wild West of its day, although the tangible benefit of its industrial past went into the pockets of the masters rather than the people of Amlwch itself. Had copper not been discovered on Mynydd Parys, Amlwch might well have remained a small village. Holyhead's fortunes over the last two hundred years have been linked to the port and the railway. Menai Bridge would probably have remained a small settlement were it not for Telford's bridge. Llangefni is a comparatively young town and its development was linked to the post road which once passed through the town towards Holyhead. With the loss of the post route in the 1820s, Llangefni had to depend on its central location, its cattle market and its businesses.

Many villages were quite busy places during the nineteenth century and they enjoyed a degree of prosperity, but various factors caused many of them to suffer a decline and lose much of their former importance. Llannerch-y-medd, for example, was once a thriving village with a busy cattle market, a shoemaking industry and a railway station. Unfortunately, the cattle market gradually moved to the more central town of Llangefni, shoemaking declined and Llannerch-y-medd's railway station closed in 1964. These factors conspired to make Llannerch-y-medd the quiet village it is today.

During the latter part of the twentieth century, a few Anglesey villages grew quite large, such as Llanfair Pwllgwyngyll and Benllech, although the majority of Anglesey's

villages are far smaller. Most villages have lost valuable amenities in recent decades. At one time every village had its own shops, post office, public house and rural craftsmen such as blacksmiths. The closure of such amenities and the infrequency of bus services have meant that country people have become more dependent on the island's towns and on motor cars.

The eighteenth-century poet, Goronwy Owen, who for most of his life lived far away from the island of his birth, described his beloved Anglesey as a gem among the seas ('Mirain wyt ymysg moroedd'). Those who know the island and love its landscape and its character will understand his words. Goronwy Owen felt a deep sense of longing for his distant homeland. Anglesey is a very special island and it inspires a sense of affection and loyalty among its people.

ABERFFRAW

Aberffraw, colloquially known locally as 'Berffro', is a small coastal village in south-west Anglesey. Today, the locality has a population of around 700. The river that flows through the village is called the River Ffraw. The name Aberffraw therefore means 'the estuary of the River Ffraw'. The parish church is dedicated to Saint Beuno who established a religious cell here early in the seventh century. Aberffraw was an important place during the time of the Welsh Princes with a Royal Court in the village. However, no traces of the court now remain.

Today, Aberffraw is a small quiet community with few amenities. There has been comparatively little modern development and the village has retained its old-fashioned atmosphere. It is mostly noted for its popular sandy beach, sand dunes and coastal walks. There are two public houses in the village, a shop and a heritage centre. Trwyn Du, near the sandy beach of Traeth Mawr, is the site of an early Bronze Age burial mound. A few stones can be seen protruding through the grass. The old narrow bridge over the River Ffraw, now closed to vehicular traffic, was built by Sir Arthur Owen of the nearby Bodowen Estate in 1731. The author William John Griffith (1875–1931) was born at Aberffraw. He is best known for the popular book called *Storïau'r Henllys Fawr* (*Tales of Henllys Fawr*) which was published in 1938.

AMLWCH

Amlwch is situated on Anglesey's rugged northern coast and has the distinction of being the most northerly town in Wales. Its population in 2011 was 3,789, which is roughly the same as that of Menai Bridge. The name 'Amlwch' consists of two elements: 'am' meaning around and 'llwch' meaning lake or inlet. 'Llwch' has the same origin as the Scottish 'loch'. The town is close to *Mynydd Parys* (Parys Mountain). Amlwch is divided into two distinct parts: the town of Amlwch itself, which is a mile or so from the sea, and Amlwch Port (Porth Amlwch) which has a rich maritime history.

In 1766 Amlwch was described as a hamlet of only six houses. However, both Amlwch and Amlwch Port grew considerably during the late 1700s as a result of the discovery of a large body of copper ore on nearby Mynydd Parys which is 494 feet high. The discovery was made by Rowland Pugh (or Rolant Puw) on 2 March 1768; he was rewarded with a bottle of whisky and a rent-free house for the rest of his life.

Mynydd Parys derives its name from a certain Robert Parys (1373–1408) who was given land on *Mynydd Trysglwyn* (the original name of the mountain) at the beginning of the fifteenth century. Parys was appointed by the King to collect taxes and fines from those in Anglesey who had supported the uprising of Owain Glyndŵr. Copper deposits were investigated in the 1570s but the cost of exploiting them was too high. Copper ore had been excavated on a much smaller scale before this and there is evidence that the mountain had been exploited as long ago as 2000 BC.

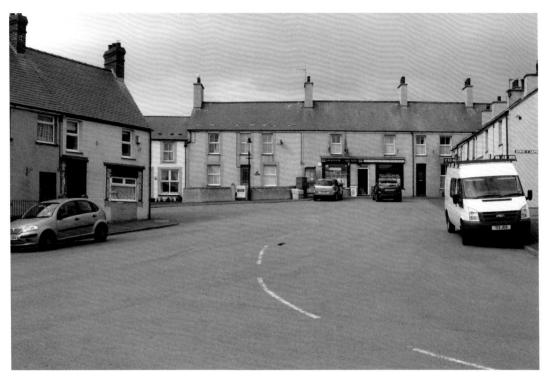

The village square, Aberffraw.

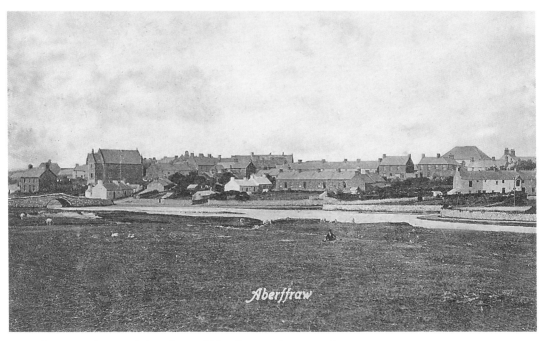

The River Ffraw and the village of Aberffraw, early twentieth century.

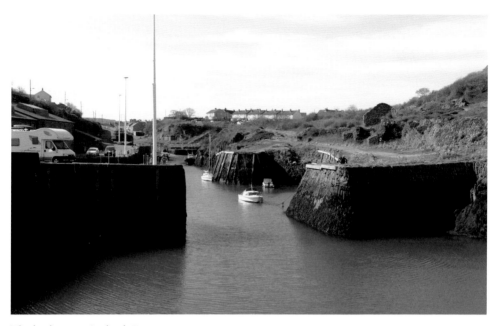

The harbour at Amlwch Port.

At the beginning of the copper boom, there were two rival companies on Mynydd Parys: the Mona Mine Company and the Parys Mine Company. The profits of the mining companies were huge. For example, those of the Mona Mine Company had steadily increased from £5,337 in 1787 to almost £17,000 in 1793; this enabled the Plas Newydd family to rebuild their mansion overlooking the Menai Straits. In contrast, Amlwch miners and their families lived in poverty in dirty, unsanitary hovels with the constant threat of cholera.

By the turn of the century with the copper industry thriving, the population in 1801 was 4,977. Amlwch was then the second largest town in Wales after Merthyr Tydfil. In 1831 the population had risen to 6,285 which made Amlwch a little larger than Cardiff. In the peak period 1,500 men, women and children excavated 80,000 tons of good quality ore a year. However, fortunes suffered as the ore quality declined.

In the early days of the copper boom a lawyer named Thomas Williams (1737–1802) had become prominent in the affairs of the mountain and had become one of the most influential industrialists of his day. After the death of Thomas Williams, the Earl of Uxbridge secured control of the Mona Mine Company, and this is when James Treweek was appointed as mine agent and brought a number of other Cornishmen to Amlwch. Treweek introduced new mining methods and deeper shafts were sunk. The main office of the Mona Mine Company was at building called Mona Lodge which still stands in Amlwch. In the same period, Amlwch Port became an important and thriving port.

A private academy was established in Amlwch in 1814 by master mariner William Francis; the school taught reading and writing but also offered those skills which boys preparing from a nautical career would need. In a town with a strong seafaring

Mona Lodge, Mona Street, Amlwch, was used as offices for the Mona Mine Company.

tradition there was considerable demand for such skills. The school was highly successful for decades but came to an end in 1853.

A few small ships had been built at Amlwch Port towards the end of the eighteenth century and the beginning of the nineteenth century. An era of building larger ships began in the 1820s when the Treweek family (James Treweek and his son Nicholas) began shipbuilding. They eventually controlled almost seventy vessels. The master of one of their ships was Captain William Thomas. He started another shipbuilding company in 1858 which expanded rapidly over a number of years. These companies did a brisk trade carrying copper ore. However, when the railway reached Amlwch in 1867, the cost of moving goods by rail undercut the cost of shipping by sea and this dealt a blow to the shipping businesses. Nevertheless, shipbuilding continued up to the beginning of the twentieth century. Thereafter the industry went into serious decline and after the First World War, the yards were mostly engaged in repair work and the breaking up of old ships for scrap.

Amlwch was famed throughout Anglesey and beyond for its large number of public houses. According to the Beer Act of 1830 any householder, on payment of a fee, could apply to sell beer on his or her premises. Some of those who sold beer from their own homes in this way were widows of men who had died on Mynydd Parys and who needed to make a living. A woman called Sarah M. Matthews (who was a daughter of the famous publisher Thomas Gee and wife of a local bank manager) tried to combat the drinking culture by establishing a temperance establishment. Excessive drinking was one of the reasons for the extreme poverty in Amlwch during the copper boom years of Mynydd Parys.

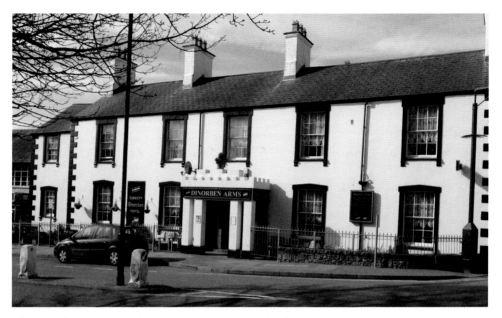

The Dinorben Arms Hotel in Dinorben Square, Amlwch.

The miners of Mynydd Parys were also equally fond of smoking. This gave rise to Amlwch's tobacco industry which lasted well over 100 years. Raw tobacco leaf was brought to Amlwch and was processed locally into snuff, cigarettes, pipe tobacco and chewing tobacco. A number of companies were involved. Other industries in Amlwch were clog-making and the manufacture of tallow candles (for use by underground miners on Mynydd Parys).

Like most towns of a similar size, Amlwch made a tentative entry into the modern age with the building of a gas works, on Lôn Goch (behind Saint Eleth's church), in 1863. This meant that the town's streets could be lit for the first time. In the same year, in common with most urban areas, Amlwch acquired a council cemetery, located some miles away at Burwen. In 1877 the telegraph system reached Amlwch.

Most towns in the mid-nineteenth century aspired to be part of Britain's expanding railway network. The Anglesey Central Railway was a single track branch line which ran from Gaerwen (where it branched off the main Chester to Holyhead line) to Amlwch. The line was completed as far as Amlwch in 1867. It was hoped that the line could take advantage of business from Mynydd Parys, but the glory days of copper production were almost over when the line opened. The Amlwch line was closed in 1964 as a result of the Beeching report. However, the Octel Company (which had a one mile private extension to the line from Amlwch station to the works at Amlwch Port) used the line for freight operations until 1993. Since then, the line has been idle and has deteriorated. However, a group of enthusiasts have striven since the early 1990s to reopen the line as a heritage railway.

By 1851, the population had declined to 5,813. By the 1880s many, though not all, of the mine workings had been abandoned and the smelters were little used. The population of Amlwch had fallen to 4,443 by 1891 and by 1901, it was 2,994.

Unlike Llangefni, Holyhead and Menai Bridge, Amlwch was late entering the electrical age. It was not until 1935 that the town's streets were lit by electricity and some homes were able to discard the candle and the paraffin lamp, although some would not enjoy the benefits of electricity until after the war. The 1930s were a time of hardship; the depression forced a number to leave Amlwch to seek work, such as on the whaling ships.

In the period after the Second World War, Amlwch was endeavouring to attract industries to the town in order to provide employment. One of the first major companies to locate in Amlwch was the Associated Ethyl Company which opened a plant to extract bromine from sea water in Amlwch Port in 1953. The railway line was extended from Amlwch station to the plant so that supplies could be brought to the factory by rail. The plant was taken over by the Great Lakes Chemical Company in the late 1990s, but it closed in 2005. The construction of the Wylfa Nuclear Power Station near Cemaes began in 1964. Wylfa provided the area with much needed construction jobs, although when Wylfa was complete, in 1971, the number employed was considerably less. Other companies were also drawn to Amlwch, such as the Rehau plastics factory which has been a major employer since 1974. The Shell oil terminal was short-lived and provided few local jobs.

Some notable features in Amlwch include the Grade II listed Mona Lodge, in Mona Street (which was the location of the Mona Mine offices and the residence of James Treweek between 1811 and 1847); Saint Eleth's parish church, in Dinorben Square; the unusual Roman Catholic Church in Bull Bay Road; the historic buildings in Amlwch Port and nearby Mynydd Parys.

Notable people connected with Amlwch include Thomas Williams (1737–1802), the 'Copper King'; mine manager James Treweek (1779–1851); artist William Roos (1808–1878); poet, musician and author Owen Griffith (1851–1899) who wrote a book on the history of Mynydd Parys; First World War hero William Williams (1891–1965); Ian Fraser Kilmister, born 1945, guitarist with the group Motörhead and known as 'Lemmy'; Iwan Llewelyn Jones, one of the most successful pianists in Britain; and Andy Whitfield (1972–2011) was born in Amlwch and became an actor in Australia.

BEAUMARIS

Much of the town of Beaumaris stands on a flat area, formerly a marsh, next to the sea. The land to the north is considerably higher and the steep *Allt Goch* (Red Hill) descends into the town. It is by far the smallest of Anglesey's towns with a population about 2,500 in 2011. The name Beaumaris is derived from the Norman French *beau marais* (beautiful marsh). The correct pronunciation of the name is 'bew-mariss', rather than the frequently heard mispronunciation 'boh-mariss'.

The main settlement in this part of Anglesey in the thirteenth century was Llan-faes which was a substantial community and busy port. Ships from Llan-faes were trading with Liverpool, making it an important port and trading centre as well as a fishing centre. After the 'last prince' Llywelyn ap Griffith (also known in Welsh as Llywelyn ein Llyw Olaf) was killed by English troops at Cilmeri, Powys in 1282, Edward I decided to build a ring of castles to strengthen his grip on North Wales. During a rebellion in the winter

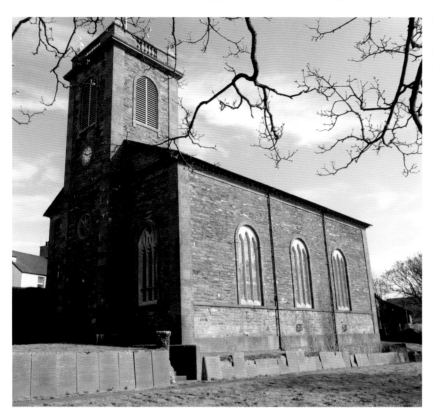

St Eleth's
Anglican
church,
Amlwch, was
built in 1800.

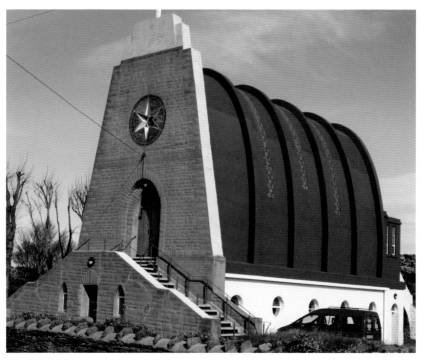

The Roman
Catholic
church, Bull
Bay Road,
Amlwch, was
completed
in 1937.

of 1294–1295 led by Madog ap Llywelyn and supported by the people of Llan-faes, the unpopular Sheriff of Anglesey, Sir Roger de Puleston was hanged. Edward I responded by deciding to build a castle at Beaumaris and the work began in 1295.

The town was given a royal charter in 1296 and there were ninety burgesses (or citizens). English settlers were encouraged to live in Beaumaris and Llan-faes was destroyed. In 1303 the entire Welsh population of Llan-faes was moved to Rhosyr, which was then renamed Newborough. As Llan-faes disappeared, its business was transferred to Beaumaris which began to develop and prosper. In 1400 the Welsh famously rebelled under Owain Glyndŵr and Beaumaris castle was retaken and held by Welsh rebels for a brief period between 1403 and 1405. Following this period of unrest, it was decided to build a wall to defend the town; it was completed in 1414. There was always tension between the Welsh and the English occupiers of Beaumaris. In 1440 Welsh nobleman Dafydd ab Ieuan ap Hywel died in an armed clash with the English; this incident is known as the 'Black Affray of Beaumaris'.

The Bulkeley family, who would become a major force in Beaumaris and Anglesey over many centuries, came from Cheshire to Beaumaris in the 1440s. Beaumaris became Anglesey's county town in 1549, and remained so until the more central town of Llangefni became the administrative centre in 1895. In 1646, the castle, which had seen little use for some time, was captured by Parliamentary forces during the Civil War, but was retaken by the Royalists in 1648. By Elizabethan times Beaumaris was a thriving commercial town and this continued for a considerable period. At this time

Beaumaris Castle was built by Edward I. Work commenced in 1295.

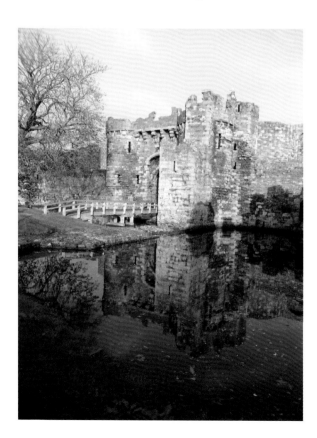

the sea came right up to the castle and Beaumaris ships traded in distant ports and the town's English merchants thrived. The population of the town in 1563 was 555 and it was Anglesey's largest settlement. By 1670 the population had increased to 710 but Beaumaris was then the second largest town, Holyhead being the largest. This was a sign of things to come – although Beaumaris could still boast more ships than any other Welsh port in 1780, Holyhead gradually became the main port for the Irish trade and Amlwch assumed great importance for the copper trade.

Under a municipal charter granted by Elizabeth I in 1562, the Borough of Beaumaris was entitled to return its own Member of Parliament. The MP would be elected by the corporation which was under the control of the Bulkeley family. This was an example of a 'rotten borough'; Beaumaris continued to elect its own MP until 1832 when it joined with Amlwch, Holyhead and Llangefni as the Anglesey 'boroughs'.

The Beaumaris Grammar School was established in 1603 on the site of an old tannery. The school was endowed by David Hughes, who lived in Norfolk but was originally from Llantrisant, who left money in his will. The Welsh Intermediate Education Act was passed in 1889 and Beaumaris Grammar School was transferred to the local authority in 1895. It became a comprehensive school in 1953, in common with all Anglesey's schools. David Hughes' School was transferred to new buildings in a more central location, Menai Bridge, in 1962. Most of the Beaumaris buildings were demolished and a library and community centre now occupy the site.

Originally Beaumaris was on the main London to Holyhead post road and this traffic was very important to the town. The route crossed from Abergwyngregyn across the Lafan Sands and the short final hop over the water to Beaumaris was by ferry. From Beaumaris, the route went up Red Hill, through Llansadwrn, Rhoscefnhir, Ceint, Llangefni and Bodedern before reaching Holyhead via Four Mile Bridge. However, the Lafan Sands was a very perilous place which could only be traversed safely at low tide. In 1718 this route was abandoned by the postal authorities in favour of the Porthaethwy ferry which crossed the Menai Straits at its narrowest point. The route then passed through Penmynydd and then continued on through Llangefni in the same way as before. Thus Beaumaris was bypassed and this was a considerable blow.

The roads in the Beaumaris area were very poor and it was not an easy place to reach from other parts of Anglesey. After the Porthaethwy ferry became more important, it was vital that there was a good road link between Beaumaris and Porthaethwy. At the beginning of the nineteenth century, the Porthaethwy to Beaumaris road was via Llandegfan and was in a poor condition. In 1805 Lord Bulkeley paid £3,000 for the construction of a new coast road between Beaumaris and Porthaethwy, but the County paid for the bridge over the River Cadnant (on the outskirts of Menai Bridge). This road gave Beaumaris better access to the Garth and Porthaethwy ferries.

During the nineteenth century, Beaumaris entered a new era as a holiday destination. In 1822 the St George Steam Packet Company began a regular service between Liverpool and Beaumaris (and Menai Bridge). The journey from Liverpool to Beaumaris took five hours. The popularity of these pleasure steamers increased rapidly in the 1830s and Beaumaris gradually developed as a genteel, fashionable watering place. The Bulkeley Hotel was built in 1831, and together with the long-established Bull's Head and Liverpool Arms, catered for the increasing numbers of middle class visitors from the north of England. Improvements were carried out to draw more visitors. The Green was drained and levelled in 1823 and streets were widened and resurfaced. In 1826 the terrace known as Green

Edge was built by the borough council and rented out. The Borough Council also built the grandiose Victoria Terrace. By 1831 the population had reached 2,497.

Although Beaumaris still had 236 registered sailing vessels in 1836, it had been overtaken by Holyhead by the 1840s. So Beaumaris slowly assumed its status as a playground for the affluent. It became a centre for such activities as the Anglesey Hunt, regattas and banquets with the splendid mansion of Baron Hill being a centre for many of these activities. Most of the rich visitors saw little of Beaumaris' squalid back streets where ill health and poverty could be found in abundance.

The mid-nineteenth century was a time when the railways were creating profound changes throughout Britain. The residents of Beaumaris saw the railway as a means of further developing the tourist status of their town. In 1845 the Beaumaris and East of Anglesey Junction Railway Company was established to construct a line from Llanfair Pwllgwyngyll to Beaumaris as soon as the main Chester to Holyhead line had reached Llanfair Pwllgwyngyll. The line was never built. A further railway scheme was proposed in 1887 and an electric tramway in 1897. Neither project came to fruition; thus Beaumaris was never connected to the railway network.

In 1856 Beaumaris, along with Holyhead, became the first town in Anglesey to be provided with gas for lighting the streets. The gas works were at Mill Lane, but no trace of it now remains. Gas for domestic lighting came a little later but could only be afforded by middle-class families.

Increasingly the town's water supply was inadequate to cope with the town's inhabitants and the constant flow of visitors and in the 1850s Beaumaris began to

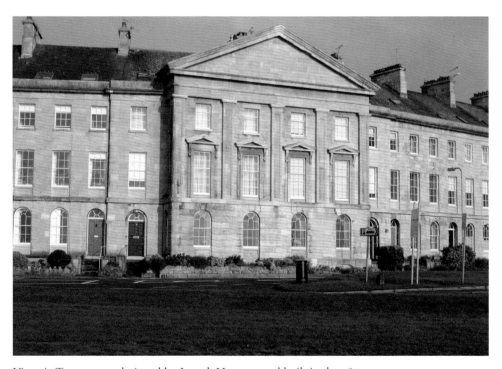

Victoria Terrace was designed by Joseph Hansom and built in the 1830s.

Archway in Castle Street, Beaumaris.

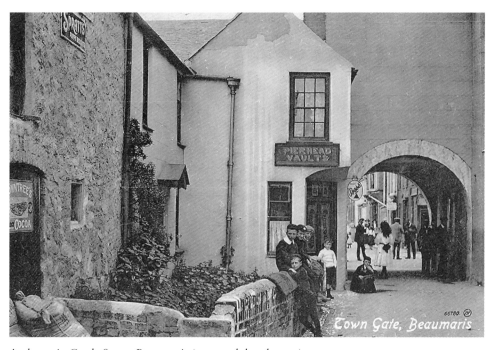

Archway in Castle Street, Beaumaris (postcard dated 1915).

develop a system where water from Llyn Pen y Parc was piped down to the town, although it would be many years before all the homes in the town benefitted from piped water. Beaumaris also acquired a non-denominational public cemetery on a two acre site on the outskirts of the town in 1861.

In 1891 the Liverpool and North Wales Steamship Company was established and a prosperous period began with thousands of day-trippers arriving in Beaumaris on board a fleet of steamers, *La Marguerite*, *St Tudno*, *St Elvies* and *Snowdon*. Holidaymakers were also well catered for with a considerable number of hotels and boarding houses. The Victorian period saw a number of houses built in the town; the cottages in Wexham Street were built on a French model for the Bulkeley family in order to house their workers. The large red brick middle-class houses in Margaret Street are late Victorian.

The First World War claimed the lives of forty-five Beaumaris men; the post-war years saw an economic boom, but this was very short-lived and a deep depression developed in the late 1920s and 1930s. Beaumaris saw many of its people forced to move to find work. The population of Beaumaris fell from 2,010 in 1911 to 1,568 in 1931. The pleasure steamers stopped calling at Beaumaris during the 1930s and this led to a further decline in the town's fortunes. The interwar period saw Beaumaris rather belatedly entering the electrical age when an electricity supply reached the town in 1935. The poorest homes, however, still continued to use paraffin lamps and candles. In 1938 thirty new council houses were completed and these were equipped with electricity, baths and indoor toilets.

One of the finest houses in Anglesey, the magnificent mansion of Baron Hill in Beaumaris (which had not been occupied by the Williams-Bulkeley family since the

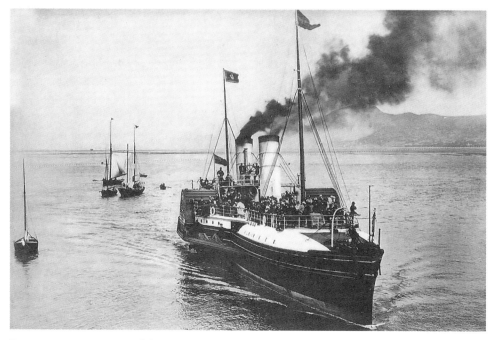

La Marguerite was one of the steamers which called regularly at Beaumaris at the turn of the twentieth century.

1920s) was used during the Second World War by the Royal Engineers, the Welsh Guards and other regiments at various times. It was also used as a centre for Polish servicemen and as a small military hospital. There was a fire in Baron Hill during this period and this, together with the theft of lead from the roof, began the sad decline of a once beautiful mansion (built in 1776) into the total ruin which it has now become.

Following the war, Beaumaris built a number of council houses in the 1950s; the attractive Maes Hyfryd estate was designed by Sidney Colwyn Foulkes and won an award. The development of Cae Mair for private housing increased the population of the town in the 1970s and 1980s. The stone circle on the Green dates from the 1996 Anglesey Eisteddfod.

Apart from two banks, there are no nationwide shopping chains or large supermarkets represented on the streets of Beaumaris. Instead, locally owned independent shops are the norm. The town remains dependent on tourism and the pier, newly-refurbished in 2011, enhances the town's facilities. The Beaumaris Leisure Centre is run by a community group, and there is an annual Menai Straits Regatta (in August) and the annual Beaumaris Festival is held in May.

Notable features in Beaumaris today include the parish church of St Mary and St Nicholas in Church Street; the castle (which is a World Heritage site); the imposing Victoria Terrace which overlooks the green; the Bulkeley Arms Hotel; the gaol, built in 1829, which houses a museum; the courtroom, which dates from 1614; the Tudor Rose, a fifteenth-century town house; the Old Bull's Head; the Liverpool Arms Hotel; the George and Dragon Hotel; and the ruined mansion of Baron Hill.

Notable people connected with Beaumaris include Lewis Roberts (1596–1640); wealthy lawyer and landowner Owen Hughes (?–1708); Richard Lloyd (or Llwyd) (1752–1835) who was known as the Bard of Snowdon; John Williams (1833–1872) who was a lawyer and antiquarian, and artist Karel Lek (born 1929).

BENLLECH

The name Benllech contains the elements 'pen' (meaning 'head' or 'top') and 'llech' (meaning circular stone). The name Benllech therefore means 'head rock' or 'capstone'. The village took its name from a farm called Tyddyn y Benllech (also known as Tyddyn Iolyn), which is said to be the oldest house in the village. Near the village is the scattered community of Tyn-y-Gongl, which is part of the rural agricultural parish of Llanfair Mathafarn Eithaf. 'Llanfair' means 'the church of Saint Mary'. Since there are number of places with the name Llanfair, it is usual to differentiate between them by adding another word, or words. 'Mathafarn' is an open area having a tavern. 'Eithaf' means 'furthest' or 'most inaccesible'. Consequently, the parish name means 'church of Saint Mary on the open area with a tavern which is the most inaccessible'.

Benllech grew significantly during the latter half of the twentieth century and today it is a large village with a substantial number of residential estates. The area has a population of 3,400 and is Anglesey's fifth largest community. There are a number of shops in the village which has been a typical holiday destination for generations. It has a large sandy beach which is very popular with tourists and there are a number of caravan parks in the area.

The parish church of St Mary and St Nicholas, Beaumaris.

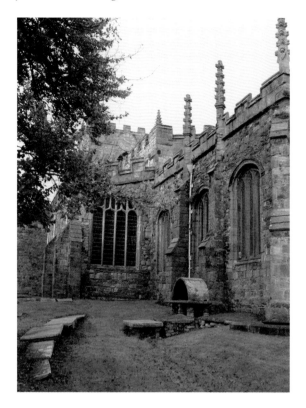

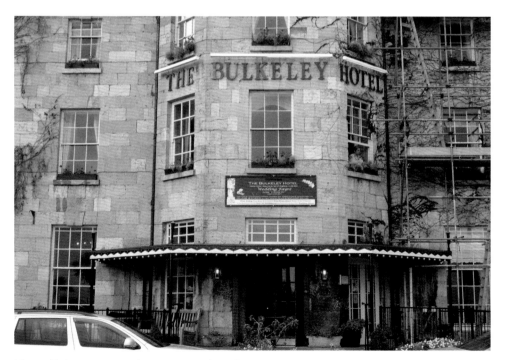

The Bulkeley Arms Hotel, Beaumaris, dates from 1832.

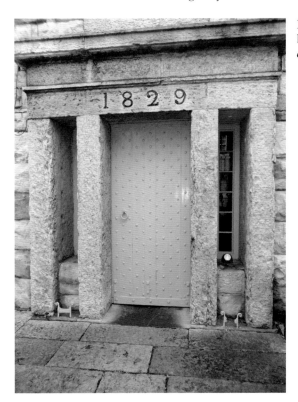

Beaumaris Gaol was designed by Joseph Hansom and completed in 1829.

Beaumaris Courthouse was built in 1614.

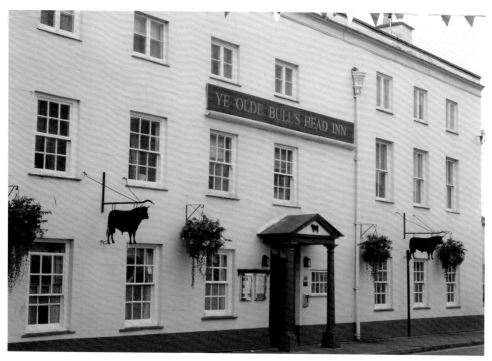

The Old Bull's Head was originally built in 1472 and rebuilt in 1617.

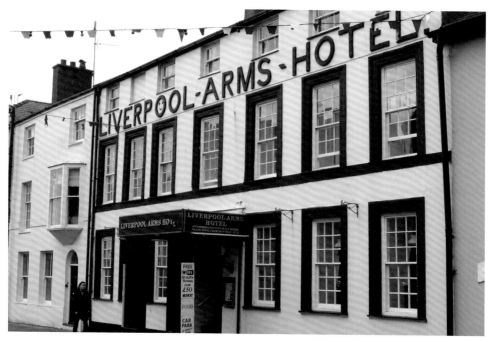

The Liverpool Arms was built in 1700.

The Beach at Benllech.

The railway reached the outskirts of Benllech in May 1909. The station was known as 'Benllech and Red Wharf Bay'. It was hoped that the railway would bring additional prosperity to the village at a time when Benllech; was beginning to develop as a seaside resort. It finally closed in 1950. The station house is the only feature of the station which remains.

Notable features in the area include the eighteenth-century mansion known as Y Glyn; Tyddyn Iolyn, the oldest dwelling in Benllech; and Neuadd Goronwy Owen, the village hall, named after local poet Goronwy Owen, which was opened in the 1950s.

Notable people connected with the area include poet Goronwy Owen (1723–1769) who was born at Y Dafarn Goch in the parish; poet Owen Jones (1770–1855), also known by his bardic name, Gwilym Mathafarn; broadcaster Gwyn Llewelyn (born 1942); and stage, television and film actor J. O. Roberts.

BODEDERN

Bodedern is the name of a village as well as a fairly large parish in the west of Anglesey. The population is around 1,100. There are two elements in the name Bodedern. 'Bod' means dwelling place and 'Edern' is the saint to whom the church is dedicated. The main industry in the Bodedern area is farming. Llyn Llywenan lake is about a mile north-east of the village. Bodedern has retained its character with comparatively little

housing development in recent decades; it is the only Anglesey village to have both a primary and secondary school.

Early Christian burials have been discovered at Arfryn where around ninety graves have been identified. These are described as long-cist graves, where the bodies were buried in coffins made of stone slabs.

There were two influential estates in the locality. The Presaddfed estate and the Tre Iorwerth estate are both about a mile east of the village. One member of the Tre Iorwerth family, the Reverend Hugh Wynne Jones (1751–1809) was very influential in the area.

Every year Bodedern has a festival called *Gŵyl Mabsant*. It is a week-long festival which begins on the first Saturday in May. The festival begins at the church.

Notable features in the area include the country mansion and estate of of Plas Presaddfed; the Presaddfed Burial Chamber and the Stanley Pump.

Notable people include the Reverend Huw Jones (1831–1883) and John Hughes (1855–1886) who ran a school in Llanddeusant and a collegiate school in Bodedern.

BODFFORDD

The name Bodffordd contains two elements: 'bod' (dwelling) and the English word 'ford'. There was a ford nearby. Bodffordd has also been called 'Bodffordd Esgob' and 'Bodffordd Ddeiniol' at times in the past.

Bodffordd is in the parish of Heneglwys (meaning 'old church'). Bodffordd is a small village surrounded by a large area of agricultural land. The village has retained its rural character. Today, there are few shops and amenities in the village but there is a small industrial estate. The population of the area is less than 1,000.

The nearby Cefni reservoir which is north-east of the village was completed in April 1951. This was a large scheme which was intended to provide for the Anglesey's water needs for the forseeable future.

Notable people connected with Bodffordd include actor and comedian Charles Williams (1915–1990); the Revd Idris Charles Williams, broadcaster, comedian and son of Charles Williams; and musician and television presenter Alwyn Humphreys (born 1942).

BRYNGWRAN

The original name for this area was Llechylched and a stone (*cromlech*) from the Neolithic period can be found on a small hillock. The name Bryngwran translates as 'the hill of Gwran'. 'Gwran' is probably a personal name. Like so many villages, Bryngwran has few amenities today, although the local public house, the Iorwerth Arms, was reopened as a community pub in 2014. The population of the area (including the smaller communities of Capel Gwyn and Engedi) is less than 800.

Among the notable people connected with the area are William David Owen (1874–1925), author of the historical novel *Madam Wen* (*The White Lady*), and Caradog Evans who became headmaster of the new Ysgol Syr Thomas Jones, Amlwch, when it opened in the early 1950s and he stayed there until his retirement in 1962.

BRYNSIENCYN

Brynsiencyn is a fairly small village in the parish of Llanidan in the south of Anglesey. The place name 'Brynsiencyn' means 'hill of Siencyn'. The forms 'Bryn Shenkyn' and 'Bryn-siencyn' have been used in the past. The village has retained much of its character with comparatively little housing development in recent years.

The area around Brynsiencyn was traditionally a farming community, but from the mid-nineteenth century many of the people went to search for work in the quarries of Snowdonia and travelled there by ferry across the Menai Straits.

The Tal y Foel Ferry, south of the village, commenced in 1425. There was a small harbour opposite the Mermaid Hotel. There was a slipway by Barras and a pier was constructed opposite Foel Farm. The crossing could be dangerous when the tide was high and the weather inclement. On one occasion eighty people were lost when the Abermenai ferry sank. This was the worst tragedy on any Anglesey ferry. The last of the ferries closed in 1954.

Notable features in the area include Caer Leb which was in use during the Roman period; the Neolithic tomb of Bodowyr; the former corn mill of Melin Bodowyr and Castell Bryngwyn.

Notable people connected with the area include historian Henry Rowlands (1666–1723); educationalist Sir Hugh Owen (1804–1881); Thomas Williams (1737–1802) who developed the copper mining operations on Mynydd Parys (see Amlwch); the Reverend Dr John Williams (1854–1921), one of the most famous preachers in Wales; Sir Ellis Jones Ellis-Griffiths (1860–1926), Anglesey's Liberal MP from 1893 to 1918; John Jones (1818–1898) who was a talented self-taught amateur astronomer, known as 'John Jones y Sêr' (John Jones the Stars); and singer and actress Margaret Williams.

BULL BAY

See Porth Llechog.

Capel Horeb, Brynsiencyn, where the famous Dr John Williams was minister between 1878 and 1895.

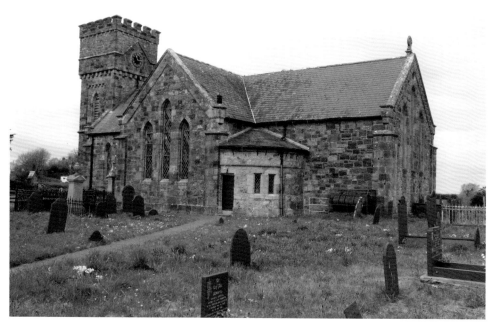

Llanidan parish church was built in 1841.

CAERGEILIOG

The name Caergeiliog contains the elements: *caer* (meaning 'fort') and *ceiliog* (meaning 'cockerel'). The significance of *'ceiliog'* is unclear, but it may refer to cock-fighting circles near the village. Its proximity to Holyhead has meant that a certain amount of modern housing development has occurred in the village in recent decades.

There are a number of small lakes in the area. Llyn Traffwll was an important reservoir supplying water to the residents of Holyhead. Lake Penrhyn is the second largest lake in the area and Llyn Dinam is in western side of the village. During the Second World War, the Caergeiliog area was transformed when the RAF moved to the sandy area of nearby Tywyn Trewan. As a result, the population of the area increased and the RAF became a very important local employer. The RAF base still remains open.

A notable feature of the village is the tollhouse at the western edge of the village. It dates from the 1820s and is one of a number built when the new Post Road was constructed by Thomas Telford.

A notable person connected with Caergeiliog was Mathew Richard Williams (1876–1964) who was a well-known local poet and composer of ballads. He was known as 'Mathew Bach' (Little Matthew).

CAPEL COCH

Capel Coch is a small village in central Anglesey. The name Capel Coch means 'red chapel'. Capel Coch is a residential area with few amenities. Nearby is the country mansion of Plas Tre-ysgawen which today is a high class country hotel and restaurant.

Notable people connected with the area include mathematician William Jones (1674–1749) who introduced the symbol π; and journalist and broadcaster Vaughan Hughes (born 1947).

CEMAES

The name Cemaes comes from the old word *'camas'* meaning a 'loop' or 'meander'. The village name is occasionally spelt Cemais. At one time, the village was called Porth Wygyr ('harbour of the River Wygyr'). The river Wygyr enters the sea on the beach. Cemaes was once a centre for shipbuilding and exporting, but this declined in the mid-nineteenth century following the arrival of the railway at nearby Amlwch.

Capel Caergeiliog (*right*) was built in 1872 and the hall (*left*) was built in 1930. The RAF used the hall as a control centre for a while during the Second World War.

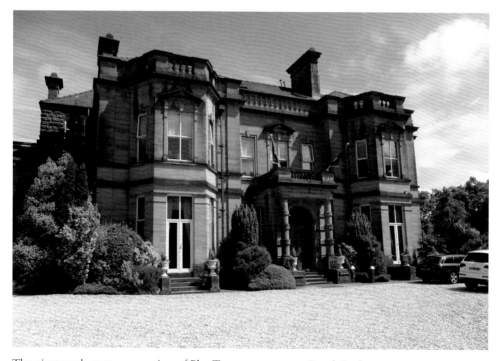

The nineteenth-century mansion of Plas Tre-ysgawen, near Capel Coch.

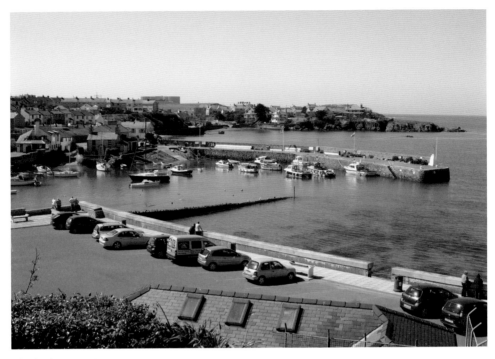

The harbour at Cemaes.

Today, Cemaes is an attractive small village (with a population of around 1,000) and has a number of shops on the main street as well as two public houses, a heritage centre and a village hall. It is the main centre on the coast of north-west Anglesey.

Notable features in the area include the Village Hall which was built for the village by David Hughes in 1889; the disused Porthwen brickworks situated on the coast, about two miles east of the village and the Wylfa Nuclear Power Station, opened in 1971.

Notable people connected with Cemaes are Thomas Lewis (1821–1897), Liberal MP for Anglesey between 1886 and 1894, and photographer Owen Richard Morris (1874–1909).

DWYRAN

Dwyran means 'two parts' which refers to the fact that the medieval settlement in this area was in two parts, known as Dwyran Beuno and Dwyran Esgob. The land between the two rivers (Braint and Rhyd) is where the village stands today.

Dwyran is a small village surrounded by a large agricultural area. It has few amenities, but there is a medical centre, a primary school and a garage. The village did not receive a piped mains water supply until 1953 and it was 1957 before the village was connected to mains electricity.

Notable people connected with the area include journalist John Owen Jones (1861–1899) who campaigned for a reduction in the working hours of farm labourers. He was often known as *'Ap Ffarmwr'* (a farmer's son); Elizabeth Ann Williams who was the author of a remarkable book entitled *Hanes Môn yn y Bedwaredd Ganrif ar Bymtheg* (*History of Anglesey in the Nineteenth Century*) which was published in 1927.

GAERWEN

Gaerwen is the main settlement in the parish of Llanfihangel Ysgeifiog (church of Saint Michael in the township of Ysgeifiog). The name Gaerwen means 'white fort'. Originally, Gaerwen was the name of a farm before being taken as the name of the village. Capel Eithin was the first known settlement in the area, dating from about 5000 BC.

About 1830 a number of people came to Gaerwen to work in the coalfield at nearby Pentre Berw. The coal mines ceased operating around 1865. In the nineteenth century Gaerwen was an important centre for the flour industry. There are two windmills in the village; one is now derelict and the other has been converted into a dwelling. Gaerwen's location on relatively high ground is a perfect location for windmills.

The village of Gaerwen today consists of settlements on each side of the road. The village grew in this way following the construction of the A5 in the 1820s. Today, the village has a few residential estates, a large hardware shop and garage, a hairdresser, a small village store and a post office.

Gaerwen also has a large industrial estate and the Morgan Evans Company operate a cattle market which was transferred to Gaerwen in 1997 from its traditional location at Llangefni. In April 2013, the Welsh Country Foods abbatoir closed with the loss of 350 jobs. The new Menai Science Park is planned to open in Gaerwen in 2017.

A notable feature in the area is Cae Eithin which dates from around 5000 BC. There are remains of a Bronze Age cemetery here where urns and pots have been found which are characteristic of the burial methods of the Bronze Age period.

A notable person born in Gaerwen was the Revd Owen Jones (1806–1889) who was the author of a number of major works about the history and literature of Wales.

GWALCHMAI

Once known as Trewalchmai, Gwalchmai takes its name from the thirteenth-century poet Gwalchmai ap Meilyr. On the village square there is a clock, erected in 1926, commemorating those who died in the two World Wars. The village is conveniently divided into two parts: Gwalchmai Isaf (around the A5) and Gwalchmai Uchaf (south of the village). Like all the communities along the A5 road, Gwalchmai benefitted from a reduction in the level of traffic resulting from the building of the A55 which was completed in 2001. Today, the village lacks amenities but it has a tavern, a shop and

a garage. A notable feature of the area is the tollhouse on the eastern extremity of Gwalchmai which was built in the 1820s. The population of the area is around 900.

The scattered community of Mona is about a mile or so east of Gwalchmai. The Mona Inn coachhouse dates from the 1820s when Telford's road (the A5) was used as the post route. Today Mona is best known for its airfield which has a history spanning a hundred years. The airfield started off during the First World War as an air base, mostly for airships. During the Second World War it was used by the RAF from 1942. Mona is also the site of the Anglesey Agricultural Society's showground. The Agricultural Show is held every year in August. There is a small industrial estate in Mona.

The notable preacher and academic the Revd Thomas Charles Williams (1868–1927) was born in Gwalchmai (see Menai Bridge).

HOLLAND ARMS

See Pentre Berw.

HOLYHEAD

The town of Holyhead is situated in the north of Ynys Cybi (Holyhead Island) which is the most westerly part of Anglesey. The town is dominated by Mynydd Twr, the mountain which forms the highest point on Ynys Cybi. Holyhead is by far the largest of Anglesey's towns with a population of over 11,200 in 2011.

The town's names have been various: Llan y Gwyddel and Eglwys y Bedd have both been recorded. In a thirteenth-century document Castrum Cuby was used; in the fourteenth century Haliheved and Holiheved as well as Caergybi were used. In the sixteenth century Kaer Kybi, The Holy Hedde and Holy Hed are recorded. On Humphrey Llwyd's sixteenth-century map, the first to be produced by a Welshman, Caer Cybi and Holy Head are used. The modern established forms are Caergybi (in Welsh) and Holyhead (in English).

Human settlement in Holyhead dates from very early times. The Penrhosfeilw Standing Stones date from prehistoric times. Holyhead Mountain or Mynydd Twr is 720 feet above sea level and is the highest point in Anglesey; on it there are a number of stone hut circles, known in Welsh as *Cytiau'r Gwyddelod* (roundhouses, literally, 'Irishmen's huts') and other buildings probably occupied over a lengthy period, from 200 BC to 500 AD. In Holyhead itself, the Roman fort is a three-sided enclosure which originally stood on the edge of the slope above the sea. The style of the masonry places it in the late Roman period.

St Cybi founded a monastic settlement (or clas) on the site of the Roman fort around AD 540. At the dissolution of the monasteries in the sixteenth century, Caergybi church continued as a parish church. In the early fourteenth century, Eglwys y Bedd was built in the south-western corner of the fort, not far from Saint Cybi's church.

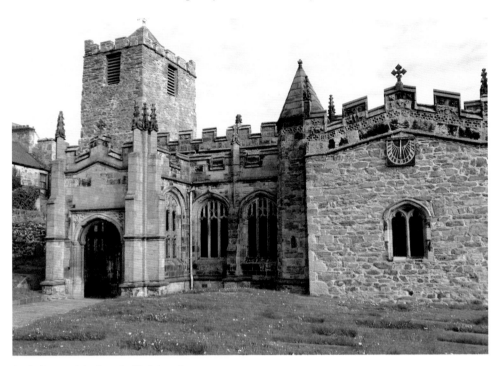

St Cybi's parish church, Holyhead.

The fourteenth-century Eglwys y Bedd is located next to the parish church.

By the last quarter of the sixteenth century, ships carrying the mail between Holyhead and Ireland were already established. At the end of the seventeenth century, it is significant that the population of Holyhead had overtaken that of Beaumaris and is estimated as 900–1,000.

On the eastern outskirts of Holyhead was the old mansion of Plas Penrhos. The old family in Plas Penrhos had the surname Owen and were a powerful family in the area. In 1763, Margaret Owen (1742–1816) married Sir John Thomas Stanley (1735–1807) of Alderley, Cheshire and the estate came into the possesion of the Stanley family. Many members of the Stanley family came to hold prominent positions: William Owen Stanley (1802–1884) became Anglesey's MP between 1837 and 1874. Another prominent member of the Stanley family was Edward Lyulph Stanley (1839–1925) who became a prominent figure in the world of education. The Stanley family were generous benefactors to Holyhead for a long time and there are a number of places in Holyhead which bear the name Stanley.

By 1801 the population of Holyhead was 2,132. The nineteenth century would be a time of huge growth for the town and two factors would dominate its development – the harbour and the railway. In 1827 the Holyhead to Liverpool Telegraph was created which involved a number of stations, which used flags. Messages about the arrival of ships off the Anglesey coast could be sent from station to station so that a message could be sent from Holyhead to Liverpool in only five minutes. The telegraph station closed in 1858 when it was superceded by the electric telegraph.

Holyhead harbour was redesigned by John Rennie and opened by King George IV on 7 August 1821 before he crossed to Ireland aboard the *Lightning*. In the same year, the Admiralty pier (1,150 feet long), the customs house, the harbour office and the lighthouse were also completed on Salt Island.

A new London to Holyhead highway (which we now call the A5) was completed in the 1820s; the Anglesey section was completed in 1826 and as part of this work, Holyhead Island was connected to Anglesey by a new embankment, known as the Stanley Embankment. The new route enabled horse-drawn coaches to complete the London to Holyhead journey in 27 hours. The Admiralty Arch, completed in August 1824, was constructed on Salt Island in Holyhead to mark the end of this road.

Although Holyhead was already well-established as a port for vessels sailing to Ireland, the authorities in London in the early 1840s were yet to make a formal decision regarding the port of communication with Ireland. This would involve constructing a railway as well as developing a suitable port. The contenders were Holyhead and Porthdinllaen on the Llŷn peninsula. The Admiralty decided in 1844 in favour of Holyhead, largely because it would be very difficult to construct a railway in the hilly areas of Llŷn. This paved the way for the Chester and Holyhead Railway Company to commence construction in 1845. This decision to make Holyhead the port for Ireland was crucial and it has steered the way for the town's development right up until the present time.

In 1845 construction began on a massive breakwater to create a larger sheltered area for ships in Holyhead harbour. Millions of tons of rocks were blasted from a quarry on Mynydd Twr and transported down by wide gauge railway. Other stones came from quarries at Moelfre and Runcorn. The breakwater was such a massive project that it took twenty-eight years to build and was finally declared complete by Albert Edward, Prince of Wales in 1873. It is 1.5 miles (2.4 kilometres) long with a 70 foot lighthouse at the end. Its construction claimed the lives of forty people and the total

Soldiers' Point, Holyhead.

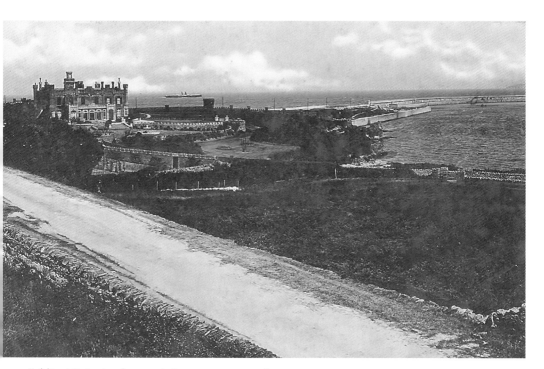

Soldiers' Point (early twentieth-century postcard).

cost was £1,250,000. During its construction, an influx of workers to the town caused overcrowding and squalid conditions and relations between Welsh and Irish workers were antagonistic. The building activity saw the population of Holyhead rise from 3,689 in 1841 to 8,863 in 1851.

The railway was complete across Anglesey by 1848 and scheduled train services ran. However, the last link in the Chester and Holyhead Railway, the Britannia Bridge, was not completed until 1850. From Holyhead passengers travelling to Ireland could cross the Irish Sea on the steamers *Anglia*, *Scotia*, *Cambria* and *Hibernia*, owned by the London and North Western Railway company.

The squalid housing conditions and the poverty in nineteenth century Holyhead gave rise to inevitable health problems. Infant mortality was very high; in 1853 for example, some 30 per cent of deaths recorded in Holyhead were children under five years old. Cholera was a constant problem with frequent outbreaks in the town. There were outbreaks in 1831, 1849 and 1866. In October 1849 alone, twenty-eight people died of cholera in Holyhead. Tuberculosis was also commonplace.

In 1855 W. O. Stanley built the Market Hall. It was busy with traders for generations but has been empty since 1997. On 29 January 1856, gas was used for the first time to light parts of the town. Crowds came out to witness the new marvel for themselves. Two days later, a dinner was held at the Castle Hotel to celebrate the event.

In 1858 Lewis Jones (1836–1904) and Evan Jones (1836–1915), launched the fortnightly satirical magazine *Y Punch Cymraeg*. This well-written and popular publication, in a similar vein to the English *Punch*, mocked almost everyone and everything and was intended for the ordinary Welsh reader. However, it was fairly short-lived, ending in 1864. The printing and publication of books (in Welsh and English) was an important small industry in Holyhead during the nineteenth century.

The prevalance of disease was partly caused by the lack of a proper water supply. In 1866 the Holyhead Water Company began to supply the town from Ffynnon y Wrach and other sources on Mynydd Twr. Llyn Traffwll, near Caergeiliog was also used. A sewerage system was also installed. On account of the cost, few properties were actually connected to the supply but taps were installed on street corners.

The Sailors' Home at Newry Beach was built by W. O. Stanley and opened by the Bishop of Bangor in 1871. The Stanley Sailors' Hospital, built on Salt Island at a cost of £1,170, was also opened in 1871. Initially it treated only sailors but later developed as a general hospital. It was taken over by the National Health Service in 1948 and closed in 1987. It became very busy during the wars of the twentieth century.

The east quay of the inner harbour was constructed in the period 1875–1880. The extensive alterations included a new station building and a hotel. The station had a glass and iron roof in the style of large city stations. These improvements enabled passengers to transfer from train to ship more quickly and easily. The new harbour, station and hotel were officially opened by the Prince of Wales (later Edward VII) on 17 June 1880 and a clock was erected to mark the occasion. The station was lit by electricity for the first time in 1895.

By 1891 the population of Holyhead was 9,610; following a reorganisation of local government, the town's Urban District Council was established in 1894. A steam driven electricity generating station was established in 1906 in King's Road and the streets were lit by electricity for the first time. The furnaces were fuelled by refuse and this gave rise to complaints about the smell. However, it would many years before

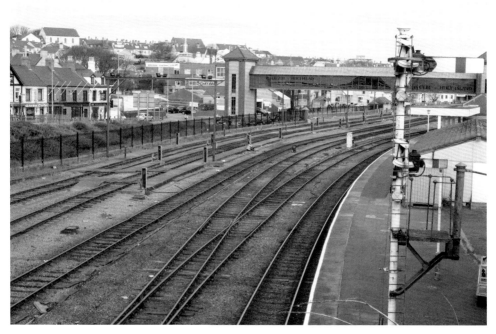

Holyhead railway station.

Holyhead Market Hall was built by W. O. Stanley in 1855.

The station clock commemorates the opening of a new Holyhead railway station in 1880.

most of Holyhead's people could enjoy the benefits of electric light in their homes. The North Wales Power Company provided electricity in Holyhead from 1932.

As soon as the First World War began in August 1914, Holyhead sprang into life and was a centre of considerable activity during the four year conflict. The Stanley Sailors' Hospital became very busy during the war. Other Holyhead buildings also took the role of 'hospitals' although in reality they were convalescent homes for the large number of wounded servicemen. The Assembly Rooms (Holborn Road), The Sailors' Home (Newry Beach), and Llys y Gwynt (Llanfawr Road) assumed this role.

Within days of the declaration of war, the Admiralty requisitioned the four LNWR ferries (*Cambria*, *Scotia*, *Anglia* and *Hibernia*) operating from Holyhead and they underwent complete transformation into armed steamers. A naval base was established in Holyhead in 1915.

On account of the colossal damage inflicted by U-boats in the Irish Sea, the Irish Sea Hunting Flotilla was established in Holyhead in 1918. Lt-Com. R. de Saumarez R. N. was appointed to organise an effective anti-submarine force. One of the ships deployed was *HMS Patrol*, under the command of Capt. Gordon Campbell VC, DSO.

At the end of 1918, Anglesey was gripped by an influenza epidemic. This was a massive pandemic which claimed millions of lives world-wide. Anglesey schools were closed for a fortnight. In Holyhead, influenza was described as 'rampant'; William Williams, his wife and two of their six children, John Thomas (aged six) and

Goronwy (aged seven months), died within a few days at the end of October. Their deaths caused great fear and distress in the town. The influenza returned in February 1919 and caused further misery.

On Saturday 14 June 1919, the Lady Thomas Convalescent Home opened. The home catered for discharged and disabled soldiers and sailors; it had three wards and could cater for thirty-eight men. The opening ceremony was performed by Mrs Lloyd George and was attended by a number of local dignitaries.

Holyhead suffered considerable losses during the First World War, and the losses at sea were particularly numerous, such as the sinking of the *Anglia* (November 1915) and the *Leinster* (October 1918). The war memorial lists the names of 287 people (including four women who worked as stewardesses on the steamers). This loss of life was a severe blow to the town. In 1920 the LNWR was awarded the contract for the mail services and four new steamers were introduced, bearing the familiar names *Anglia*, *Cambria*, *Hibernia* and *Scotia*. Unfortunately some of the ships sailing to Dublin in the 1920s were withdrawn and a lengthy trade war with the Irish Free State during the 1930s caused a huge reduction in traffic for the railway and harbour in Holyhead. Consequently unemployment and poverty increased to a high level. Some Holyhead men (as well as others from the seafaring communities of Moelfre and Amlwch) had joined Norwegian whaling vessels in the Antarctic simply because there were no local jobs. Many people were malnourished and lived in slum dwellings; ill-health was rife. Soup kitchens again provided sustenance for the poor. The population of the town decreased by about 1,000 as people sought employment elsewhere; many were never to return. However, as always, most of the middle classes were comfortably off. During the 1930s, Holyhead Council had demolished a number of slum streets and new houses had been built.

At the outset of the Second World War, therefore, Holyhead saw itself as a forgotten town, battling against the effects of deep recession and chronic unemployment. During the war, however, Holyhead was to spring into life again with new industries and the presence of servicemen from all over the world.

The Royal Dutch Navy was based at Holyhead for a time during the war. The Maritime Museum (previously the old lifeboat hut) was used as a canteen for a platoon of Royal Dutch Merchant Marines. In Saint Cybi's church there is a plaque to commemorate the Dutch servicemen who were in Holyhead during the war as well as a bronze memorial on the seafront.

In Holyhead, Salt Island and the Newry Beach area were festooned with barbed wire and gun emplacements. There were also numerous pillboxes in the Holyhead area. This was to protect the harbour area since an invasion from the Irish Sea was considered possible for a time during the conflict. Some of the Holyhead pillboxes were adaptations of existing structures; others were specially built using local stone and are still standing today. There was a radar station at South Stack. An army unit was stationed at Plas Penrhos on the outskirts of the town. A small naval base was established on Parry's Island and Bryn y Môr. The war would bring great pain and tragedy, but the economic fortunes of Holyhead and Anglesey generally were enhanced during this period; wartime production greatly reduced unemployment, although there were doubtless those in the community who did not benefit. In December 1939, a prominent Holyhead public figure remarked rather cynically, 'You cannot get anything for Holyhead unless you have a war.'

On 10 November 1939 the tragic submarine *Thetis* was dry-docked at Holyhead harbour (after being removed from Traeth Bychan, near Marianglas) where the work of removing bodies continued. Fourteen victims of the tragedy were buried in Holyhead on 16 November.

In May 1940 the ferry ship *Scotia* had been withdrawn from the Holyhead to Dublin route and was used in the Dunkirk evacuation. On 1 June the ship was attacked by enemy aircraft in the English Channel and a bomb went down the ship's funnel and caused massive damage to the engine room. About 2,000 French soldiers aboard were saved but thirty men (mostly in the engine room) were killed. Many of them were from Holyhead. At the end of August 1940, three Holyhead men, William Henry Hughes, R. Parry Williams and James Lewis were each awarded the Distinguished Service Cross for acts of bravery during this incident.

Late on Saturday afternoon 5 October 1940 the first bombs of the war were dropped on the town of Holyhead. There were huge explosions followed by anti-aircraft fire. A bomb destroyed a building known as Church House in Boston Street and there was less severe damage to dozens of houses. There were no fatalities. A dance was scheduled to be held in Church House some three hours later; the outcome could therefore have been very different. There were further bombing raids on 8 November 1940, 25 February 1941, 9 April 1941 and three raids on 6–9 May 1941. Fortunately none of these incidents caused any deaths, and there were no serious injuries.

During a six to seven month period in 1942, parts of the documentary film *Western Approaches* was filmed in and around Holyhead. The remainder of the film was shot at Pinewood Studios. The eighty-three minute film was produced by the Crown Film Unit and is said to be the first documentary to be shot in colour. It was a tribute to the Merchant Navy and told the story of a merchant vessel struck by a German torpedo in the Atlantic. Several Holyhead people worked as extras in the film. It was photographed by Jack Cardiff, later to become one of Britain's best-known cinematographers. The film was released in 1944. In June 2007 a commemorative plaque to honour the film was unveiled at Holyhead's Maritime Museum.

On 22 December 1944 an American Consolidated Liberator aircraft (known as the *Jigs Up*), having been diverted to Valley due to bad weather, ran out of fuel near North Stack. The crew of ten parachuted from the doomed aircraft; the pilot and co-pilot survived but the other eight died. They are presumed to have drowned although their bodies were never found.

After the war, which claimed the lives of 138 Holyhead people, two major priorities for the town were the provision of jobs by attracting suitable industries and the supply of suitable council housing. There were many substandard houses in Holyhead; in 1955, over 700 of them were scheduled for demolition and new homes were constructed in different parts of the town.

In November 1945 the A. C. Wells Company started producing clocks and watches at their factory in Holyhead. This company, originally from London, had relocated to Holyhead and produced precision parts for aircraft during the war, but now that the war was over, Holyhead Town Council was keen for the factory to remain in order to provide much needed jobs. The Wells Company was a large employer in Holyhead for many years after the war, producing clocks and later toys and plastic goods at their factory (Progress Works) in Kingsland. Other companies which provided much needed jobs in Holyhead in the post-war period

were Midland Electrical Manufacturing Ltd (MEM) and the Anglesey Knitting Company. All these factories have closed down.

The main employers in the immediate post-war period were the now nationalised British Railways and the ferries to Ireland. In the late 1960s a new container service started between Holyhead and the Dublin container terminal. This service was dealt a severe blow when the Britannia Bridge was damaged by fire and rendered unusable in 1970. However, the service resumed when the Britannia Bridge was reopened in 1972. Today a number of ferry services, including high-speed ferries, carry passengers, cars and lorries to and from Ireland.

During the 1960s many Holyhead people found work in the construction of the Wylfa Nuclear Power Station. As a result of the Wylfa station, the Rio Tinto Zinc Corporation and the Kaiser Aluminium Corporation decided to build an aluminium smelter at Penrhos, on the outskirts of Holyhead and this project provided further much-needed construction work as well as hundreds of permanent jobs as production operatives. The Aluminium Powder Company (Alpoco) established a smaller plant nearby. As these new industries began, the brickworks near Mynydd Twr closed in 1973; the brickworks supplied silica bricks to the steel industry for many years. Unfortunately, Anglesey Aluminium ended their smelting operations in 2009, resulting in a considerable number of lost jobs. The plant continued on a smaller scale with the recycling of aluminium until 2013 when it closed completely. A biomass power station is planned for the site and is due to open in 2017.

In 1979 the Welsh language community newspaper *Y Rhwyd* was established. It served the town of Holyhead and the surrounding villages in the west of Anglesey. It is still being published.

A major development took place when the Station Hotel was demolished in 1978 to make way for improved station and ferry terminal facilities. The locomotive yard was closed and the old steam shed pulled down in 1989. New railway buildings were completed in 1991, including a footbridge to connect the station with the town. The new Celtic Gateway bridge was opened in 2006. The opening of the new A55 expressway in 2001 brought additional ferry business to Holyhead, and articulated lorries from Britain, Ireland and Europe are a familiar sight on this road. The ferries operate from terminals located in the Inner Harbour and Salt Island. They have undergone a number of changes in recent years.

The Penrhos Industrial and Retail Estate was begun in 2003 and a number of retail outlets have since been established there, including Argos and Wilkinson. There is also a business park at Tŷ Mawr. In September 2011 the old castellated hotel building near Soldier's Point was gutted by fire. In 2012 permission was given for a large marina and housing development in the Newry Beach area. This project, which would change the character of this area completely, has met with stiff opposition from local residents. In 2013 planning permission was granted for a controversial holiday complex at Penrhos, together with other developments at Cae Glas and Kingsland. A lorry park, which caters for the large number of commercial vehicles travelling through the port, was opened at Parc Cybi in 2015.

Notable features in Holyhead today include Saint Cybi's church which was established as a religious cell around AD 550; Stanley House in Victoria Road which was built in 1801 by the Stanley family and was the home of Capt. John McGregor Skinner; the Railway Clock which commemorated the completion of improvements to the port in 1880; the

The ferry terminal, Holyhead.

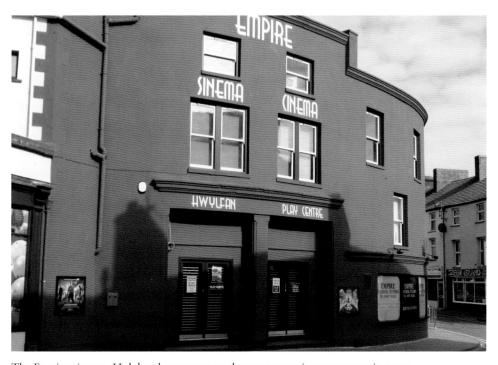

The Empire cinema, Holyhead, was reopened as an entertainment centre in 2013.

Market Hall in Stanley Street, which was completed in 1855 and became the centre for the town's trade; the South Stack Lighthouse which was originally built in 1809; Canolfan Ucheldre, a cultural centre established in 1991 which is housed in part of a former convent building; the Maritime Museum in Newry Beach; and the Breakwater Country Park.

Notable people connected with Holyhead include botanist, antiquary and letter-writer William Morris (1705–1763), one of the illustrious Morris brothers (Morrisiaid Môn); clergyman Thomas Ellis (1711–1792); mathematician, astrologer, bookbinder and author John Robert Lewis (1731–1806) who launched the famous Holyhead Almanacs (*Almanac Caergybi*) which were published for 193 years until they ceased in 1954; Captain John McGregor Skinner (1760–1832) who was a highly regarded figure in Holyhead; teacher and publisher Robert Roberts (1777–1836), the son of John Robert Lewis; William Owen Stanley (1802–1884) of Plas Penrhos who was one of Holyhead's most generous benefactors; poet and hymnwriter Samuel Jonathan Griffith (1850–1893), composer of the Welsh hymn *Craig yr Oesoedd* (Rock of Ages) which remains popular today; businessman and local benefactor Sir Robert John Thomas (1873–1951); musician William Bradwen Jones (1892–1970); the Revd Ronald Stuart Thomas (1913–2000), one of Wales' foremost English-language poets; and politician Cledwyn Hughes (1916–2001), later Lord Cledwyn of Penrhos, Anglesey's MP for nearly thirty years.

LLANALLGO

Llanallgo is a predominantly rural parish in eastern Anglesey; the largest community in the parish is the village of Moelfre. The word Llanallgo means 'church of Saint Gallgo'. In AD 872, Llanallgo was the scene of a great battle against the Danes.

Llanallgo church is where the bodies of around 140 of the passengers from the *Royal Charter* wreck were brought in 1859. The Rector of the church at the time of the tragedy, the Revd Stephen Roose Hughes (1815–1862), kindly brought the bodies to be identified into the church. Many bodies were buried together in a grave now marked by an obelisk. The Rector wrote a great number of letters to try to identify the people on the ship. Stephen Roose Hughes himself died soon after the tragedy. The famous author Charles Dickens visited Moelfre to see the full extent and effect of this horrendous tragedy and wrote about it in his book entitled, *The Uncommercial Traveller*.

Local folklore tells of a ghost who was said to roam the parishes of Llanallgo and nearby Llaneugrad. It was known as *'Bwgan y Parciau'* (Parciau Ghost) and it was believed that it was the spirit of Sir John Bodfel who lived some 300 years ago. The ghost never harmed anyone, but many were disturbed by it.

Notable features of the area include the Lligwy Burial Chamber which dates from the Neolithic or early Bronze Age; the Din Lligwy Hut Group which takes the form of round and rectangular huts within a fortified enclosure; and Hen Gapel Lligwy, a roofless ruin within a circular enclosure. Little is known about the history of this religious building.

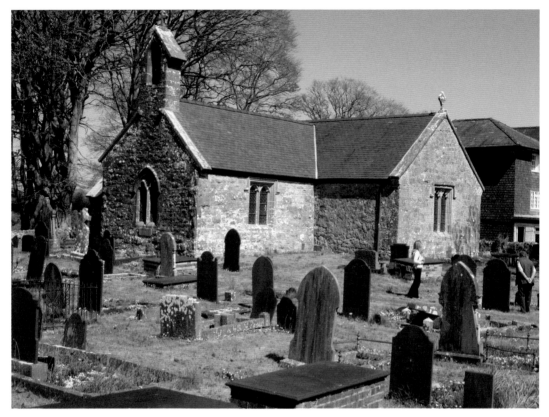

Llanallgo parish church has a strong association with the *Royal Charter* disaster.

LLANDDANIEL FAB

Llanddaniel Fab is a rural parish in south-east Anglesey. Llanddaniel Fab is also the name of the main village settlement in the parish. *Llanddaniel* means 'church of Saint Daniel (or Deiniol)'. The population is around 700.

A notable feature is the Bryn Celli Ddu Burial Chamber which dates from the Neolithic period and it is one of the most remarkable burial chambers in Britain.

Notable people connected with the area include Ifan G. Morris (1920–2006) who wrote an autobiography entitled *Atgofion Hen Filwr* in which he describes his early life in Llanddaniel and his many experiences as a soldier during the Second World War; Henry Morris (1912–1997) who was employed as butler in Plas Newydd; and Tecwyn Roberts (1925–1988) who became NASA's first Flight Dynamics Officer and helped to put the first Americans into space.

LLANDDEUSANT

Llanddeusant is a rural parish in north-west Anglesey, about ten miles from Holyhead. The main settlement is the parish is the village of Llanddeusant. Llanddeusant means 'the church of two saints'.

Notable features in the area include Melin Llynnon, a remarkable three-storey windmill built around 1775 which is now a popular tourist attraction; the watermill of Melin Howell on the bank of the River Alaw which was restored in 1975; and the Bronze Age burial site of Bedd Branwen (Branwen's Grave).

LLANDDONA

Llanddona is the name of a parish as well as a village in eastern Anglesey. *Llanddona* means 'the church of Saint Dona'. Other local names referring to Dona are Bryn Dona and Cadair Dona. Today, Llanddona has a population of around 600. There are no shops in the village, but there is a public house and a riding school.

Nearby features are Bwrdd Arthur, an early hillfort situated about a mile north-east of the village; and Din Sulwy, a hillfort dating from around 300 BC.

LLANDEGFAN

Llandegfan is the name of a coastal parish in eastern Anglesey as well as the name of a village. The name Llandegfan means 'the church of Saint Tegfan'. The village is divided into two parts, the part near Capel Barachia being called Hen Llandegfan (Old Llandegfan).

Llandegfan is about 200–300 feet above the Menai Sraits. In the period following the end of the Second World War, Llandegfan was a fairly small community made up of a few houses and farms. Since the 1960s, on account of its proximity to Bangor, the village has expanded considerably with a number of council and private housing estates.

LLANDYFRYDOG

Llandyfrydog is a large rural parish in north-east Anglesey. Llandyfrydog means 'the church of Saint Tyfrydog'. The main population centre is the tiny village of Parc. A

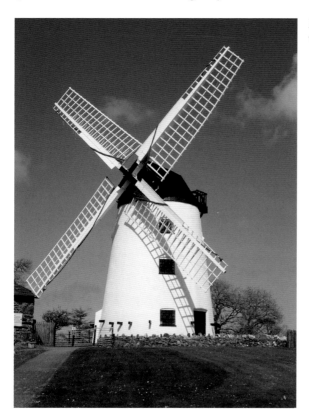

Melin Llynnon, Llanddeusant, was restored in the 1970s.

notable feature of the area is Clorach which was the home of Gwilym Tudur in the fifteenth century. The Wells of Clorach are the legendary meeting place of the two Celtic saints, Seiriol and Cybi.

Notable people include the Reverend Griffith Wynne Griffith (1883–1967) author of *Helynt Coed y Gell* (1928) and *Helynt Ynys Gain* (1939) and other books; and the Revd James Henry Cotton (1780–1862) who was active in the field of education.

LLANEDWEN

Llanedwen is a coastal parish in the south-east of Anglesey. Llanedwen means 'the church of Saint Edwen'.

Notable features include St Edwen's church, which is believed to be unique as the only church in regular use in Wales to be lit entirely by candles; the mansion of Plas Coch which dates from 1569; the mansion and gardens of Plas Newydd; Bryn yr Hen Bobl which is is a Neolithic *cairn* in the grounds of Plas Newydd.

A notable person connected with the parish was Colonel the Hon. Richard Southwell George Stapleton-Cotton (1849–1925) who lived at Llwyn Onn. He helped to establish the Newborough Mat Makers Association in 1913 and a number of small enterprises

Llanedwen parish church was built in 1856.

at Llanfair Pwllgwyngyll. He was among those who helped to establish the first branch of the Women's Institute in Britain in Llanfair Pwllgwyngyll in 1915.

LLANFACHRAETH

Llanfachraeth is a coastal parish in western Anglesey. It is also the name of the main settlement in the parish. Llanfachraeth means 'the church of Saint Machraeth'. The population of the area is less than 600. Less than a mile to the east of Llanfachraeth is the historic St Figel's church.

Notable people connected with the area include diarist Robert Bulkeley (born *c.*1570) of Dronwy; educationalist Thomas Jesse Jones (1873–1950); poet and singer Thomas Morris Owen (1885–1963); and poet, author and broadcaster Robert John Henry Griffiths (born 1928), usually known by his bardic name Machraeth.

Llanfigel parish church is no longer in regular use.

LLANFAELOG

Llanfaelog is a coastal parish in south-west Anglesey. There is also a village called Llanfaelog although the largest settlement in the parish is the coastal village of Rhosneigr. Llanfaelog means 'the church of Saint Maelog'. The area has a population of about 1,700.

The coast near Rhosneigr is particularly dangerous. In the eighteenth century, two ships, the *Loveday and Betty* and the *Charming Jenny* went into difficulty on the Llanfaelog coast and people plundered from them. Lewis Morris wrote a poem about '*Lladron Crigyll*' (The Thieves of Crigyll). In 1867, yet another ship, the *Earl of Chester*, was shipwrecked and plans were made to establish a lifeboat station. The Station opened in 1872 and it closed in 1924.

Today, the village of Llanfaelog is mainly clustered around the parish church and Rehoboth chapel, although there is another part of the village south of the railway line. There are two shops, a surgery, a garage and a community centre.

Notable features in the area include the Neolithic *Tŷ Newydd* Burial Chamber; the *cromlech* of Pentre Traeth which is about a mile to the northwest of the church on

Llanfaelog parish church was built in 1848 and modernised in 2001.

the banks of the River Crigyll; the inscribed stone known as Carreg Bodfeddan; and Barclodiad y Gawres which is a Neolithic burial chamber just outside Llanfaelog near a cove called Porth Trecastell (also known as Cable Bay).

LLAN-FAES

Llan-faes is a tiny settlement near Beaumaris. Llan-faes means 'church on open ground'.

Llywelyn Fawr (Llywelyn the Great) founded a monastery here in 1237. Before Edward I built the castle at Beaumaris, Llan-faes was a busy settlement and port. Fishing was undertaken on a large scale. Agricultural produce was exported and wine was imported from Europe. However, its commerce was transferred to Beaumaris and the local Welsh people who lived here were banished to Rhosyr in the south of Anglesey. Rhosyr became known as 'Newborough'.

During the Second World War, a factory was opened at Fryars, a large mansion with land on the site of the old monastery, for the purpose of adapting aircraft known as Catalinas. The Saunders-Roe company transferred their operations to Llan-faes from the Isle of Wight as Anglesey was perceived to be a safer location. Large sheds were built on the site and although the site is no longer used, these buildings remain.

Redundant Second World War buildings at Llanfaes.

Notable features in the area include Fryars; the mansion of Henllys Hall and Trecastell farm.

LLANFAETHLU

Llanfaethlu is a coastal parish in north-west Anglesey. The largest settlement in the parish is the village of Llanfaethlu. Llanfaethlu means 'the church of Saint Maethlu'. Maethlu the Confessor was a saint from the early Christian period who is thought to have had a religious settlement three-quarters of a mile south of the present day church. Another early Christian site is the burial ground at Hen Siop where some graves were discovered in the nineteenth century. More graves were discovered near Garreg Lwyd lodge around 1860.

A telegraph station was built in Llanfaethlu in the 1820s to carry messages about the movements of ships between the ports of Holyhead and Liverpool. The Llanfaethlu station was part of a chain of similar stations. The first message from this station was carried in 1827, but since the system depended on the observation of a semaphore signal, it was at the mercy of the weather. It was eventually replaced by the electric telegraph system later in the nineteenth century.

Notable features in the area include the mansion of Carreglwyd which was built in 1634 and revamped at the end of the eighteenth century; and Lady Reade's Coffee House, established as a temperance establishment in 1892.

Notable people connected with the area include Renaissance scholar Sion Dafydd Rhys (1534–*c.* 1609); and Richard Evans (1772–1851) who was one of the famous Anglesey bone-setters. He was descended from a foreign boy who was shipwrecked off the Anglesey coast. This boy was adopted by a childless couple.

LLANFAIR PWLLGWYNGYLL

Llanfair Pwllgwyngyll is a coastal parish and large village in southern Anglesey. The name means 'church of Saint Mary by the pool of the white hazel trees'. The village has also been called Llanfair y Borth or Llanfair-Borth. It is often known to tourists by its exceedingly long name which was originally devised by a Menai Bridge tailor called Thomas Hughes in the nineteenth century.

Llanfairpwll railway station opened in 1848, but was burnt down in 1865. A new station was subsequently built. The small goods yard handled livestock, animal feeds and flour. At the beginning of the twentieth century there was a bacon factory, an egg collecting depot, a chicory farm and a bulb farm in the village. All of these were the result of work by the Hon. Col Richard Stapleton-Cotton. The first Women's Institute in Britain was founded in Llanfairpwll on 11 September 1915.

Today, Llanfair Pwllgwyngyll is a busy village with a number of local businesses. There are a number of private residential estates in the village, as well as a number of council owned estates. The current population of the village is over 3,000.

Notable features in the area include the Tollhouse which was one of a number built on Telford's road (now known as the A5) in the 1820s; the Nelson Monument which was built in 1873 as a landmark for sailors; and the Marquess of Anglesey's Column which was built of Moelfre marble in 1816.

Notable people connected with the village include academic Sir John Morris Jones (1864–1929), Professor of Welsh at Bangor University who lived at Tŷ Coch in the village; and author and county councillor John Lazarus Williams (1925–2004)

LLANFECHELL

Llanfechell is a parish in north-west Anglesey. The largest settlement in the parish is also called Llanfechell. The parish takes its name from Saint Mechell to whom the church is dedicated. The name also occurs in the name of nearby Mynydd Mechell. Pandy, Llanfechell was established around 1430 and it was the first fulling-mill to be established in Anglesey. There were a total of six mills in the area. Llanfechell held a twice-yearly hiring fair on the square where farmers could hire farm labourers.

Llanfechell has a neat village square with an unusual whitewashed church. It has retained its old-fashioned character. Today, the population of Llanfechell (together with the smaller communities of Mynydd Mechell and Carreglefn) is around 1,500.

The railway station at Llanfair Pwllgwyngyll.

The tollhouse at Llanfair Pwllgwyngyll was built in the 1820s.

The Marquess of Anglesey's
Column, built in 1816.

The village square, Llanfechell.

Notable features include the war memorial and clock in the village square and the country mansion of Brynddu, which was the home of diarist and local squire William Bulkeley (1691–1760). His diaries reveal details of life in eighteenth-century Anglesey. William Bulkeley loved gardening and cultivated all kinds of fruits, vegetables and herbs within the walled garden of Brynddu.

LLANGADWALADR

Llangadwaladr is a fairly large rural and coastal parish in southern Anglesey. The main settlement is the small village of Hermon. Llangadwaladr means 'the church of Saint Cadwaladr'.

Notable features in the area include the church of Saint Cadwaladr, which contains a number of historic features, and Llyn Coron which is popular with fishermen.

LLANGAFFO

Llangaffo is a village and parish in the south of Anglesey. The name Llangaffo means 'the church of Saint Caffo'. Today, Llangaffo is a quiet village which, like many other villages, lacks amenities. However, there is one shop in the village.

A notable person connected with the village was the Revd William Llewelyn Lloyd, a well-known Methodist minister who served as a chaplain on the Western Front during the First World War.

LLANGEFNI

Llangefni is a town that grew around the river Cefni. This is one of Anglesey's major rivers with its source to the north in the parish of Coedana. It has been shown on maps for centuries, with various spellings, for example, Keveny (on Christopher Saxton's map of 1578) and Kevenye (on John Speed's map of 1608). The river Cefni was navigable from Malltraeth northwards as far as Llangefni up to 1760. The building of the Malltraeth cob in 1760 changed this and enabled the Malltraeth Marsh (Cors Ddyga) to be drained. Llangefni is currently Anglesey's second largest town with a population of around 5,100.

Llangefni is a comparatively young town although there has been a settlement at this location for centuries. During the sixteenth century, the settlement was often called Llangyngar, after Saint Cyngar who established the church. However, the name Llangefni (named after the River Cefni) was the one that prevailed and has now been in use for a considerable period.

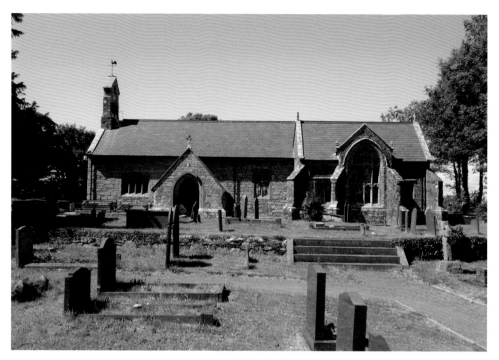

The historic St Calwaladr's church was restored in 2006.

The animal market was established in Llangefni in 1785; the sales on Wednesday and Thursday each week were a feature of life in Llangefni until quite recent times. In the old days the market was held in the street before a purpose built mart was built in the twentieth century (on the site now occupied by Asda). Llangefni's prosperity was therefore directly linked to the agricultural industry. Llangefni's general market was held on Thursdays and this still remains. Llangefni's current Saturday market is a more recent tradition.

The Pandy fulling mill (at the northern edge of the wooded area known as Nant-y-Pandy or The Dingle) ceased working early in the twentieth century. Now demolished, it was part of Anglesey's textile industry which was quite prosperous at one time, its speciality being a coarse blue cloth.

Towards the end of the eighteenth century, Llangefni was beginning to take shape as a small town. In 1801, the population was 539, but by 1831 it had increased to 1,753. At the beginning of the nineteenth century, the Rector of Llangefni, Henry Hughes described it as

A pretty little village, romantically situated in a vale with much wood about it. Ye thirteenth day of September 1785 ye first market was held at Llangefni, it consisted for that year chiefly of fresh meat, poultry and a little corn. At ye end of ye year 1810 there was in the parish 190 inhabited houses ... and the total of all persons was 965.

When Telford's new post road (now called the A5) was being constructed across Anglesey in the 1820s, the people of Llangefni were dismayed to find that it bypassed

The wooded area of Nant y Pandy, Llangefni.

the town by about a mile. It was feared that the town would suffer a loss of business, but a connecting road was constructed between the the post road and the town.

By the 1830s Llangefni, despite the loss of the post route, was well established as a small town and was beginning to emerge as a business centre for the surrounding area. Llangefni grew rapidly in the nineteenth century and consequently Victorian architecture is the dominant feature. Small shops were becoming established. For example, Richard Davies started a general store in Llangefni in 1828. He later established a large and successful timber and shipping business in Menai Bridge and a huge and highly profitable business empire was born.

In 1860 Llangefni acquired a county court. The Grade II listed building in Glanhwfa Road is still in use, opposite the old county offices. Towns all over the country were beginning to adapt to a modern age; a gas works opened in Llangefni in 1863. The town's streets could then be lit by gas.

Llangefni was dealt another blow in the late 1840s when the Chester and Holyhead Railway Company built the main railway line across Anglesey. The line took an even more southerly route than the new post road and once again Llangefni was left out of an important development.

All was not lost, however, since a local company was established to build a railway. By October 1864 the single line track was almost complete from Gaerwen to Llangefni, and the LNWR (which by then had acquired ownership of the Chester and Holyhead Railway) made the branch line connection at Gaerwen (at the Central Anglesey Line's expense). Llangefni station had a busy goods yard, handling flour, livestock,

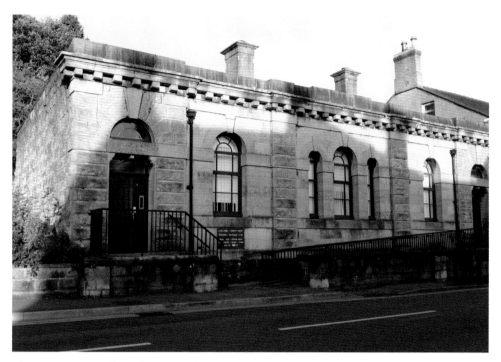

The county court, Llangefni, was built in 1860.

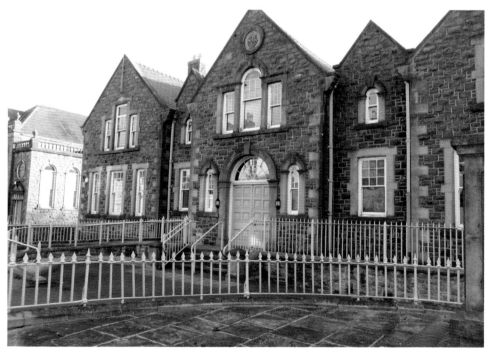

The old county offices, Llangefni, date from the end of the nineteenth century.

agricultural products and coal. This was the age when most goods were carried by rail and this practice continued well into the twentieth century. A decade or so later, in 1877, the electric telegraph reached Llangefni.

The Welsh-language weekly paper *Y Clorianydd* was established in Llangefni in 1891. Two years later, it was taken over by the North Wales Chronicle Company. *Y Clorianydd* was a popular feature of Anglesey life for decades. In the late 1960s, it was increasingly difficult to make the venture pay. The company was sold and the paper was published in bilingual form. Unfortunately, this venture was short-lived and *Y Clorianydd* ceased publication in 1969. Its last editor was Vaughan Hughes, who later became a well-known radio and television journalist and presenter.

One of the features of Anglesey life over many generations was the Hiring Fair. In Llangefni, farm labourers in search of employment would gather near the Bull Hotel and strike a deal with farmers to work on their farms for a specific period. Ifan Gruffydd (1896–1971) described the process in his autobiography, *Gŵr o Baradwys* (*Man from Paradise*). Farmers ambled through the rows of young men, assessing the possible candidates according to their needs. By late afternoon the numbers would have dwindled so that only a few were left, no doubt feeling rather uncomfortable and hoping that someone would take pity on them. The hiring fair lasted into the early twentieth century, but the increased mechanisation of farms meant that fewer labourers were needed and the practice died out.

In 1906 the mock Tudor Memorial Institute was built on the High Street. It was dedicated to the memory of Elizabeth Ann Williams and Col Robert Bramstone Smith of Plas Pencraig. It was used as a snooker hall for many years and the Llangefni library was based there for a time. The Institute, one of the more attractive buildings on the High Street, was closed in 2001 and sold in 2010 to be converted into flats. The proceeds of the sale were donated to Llangefni's schools. The Market Hotel, also on the High Street, was also built early in the twentieth century in the arts and crafts style to replace a previous building. Llangefni had a small electricity generating station before the First World War, but the provision of water was more primitive, surface wells being the main source.

In early November 1914, work began at the site of a new tuberculosis sanatorium, situated near the old windmill at Llangefni. This site was chosen because of its central location on the island and because Llangefni had an electricity supply. The hospital was opened on 23 June 1915 with modern features such as central heating and electric light.

The war was to prove costly, not only in financial terms, but also in terms of lives. Llangefni's war memorial (in Glanhwfa Road) lists the names of thirty-six local men who lost their lives. In a memorial in front of the old secondary school in Penrallt, thirty-eight former pupils who died in the First World War are commemorated.

Poverty and ill health were serious issues that were undoubtedly related; in Llangefni a clinic opened in 1918. This provision was welcomed in an age well before the National Health Service.

Some Council homes were built in Llangefni between the wars, for example the Isgraig estate in Lôn Newydd. This period also saw the demolition of slums such as the streets behind Lôn y Felin.

The Druid Hospital was an isolation hospital which had been established in First World War buildings at Mona (near Gwlchmai) during the 1920s. Since Mona was needed as an airfield during the Second World War, the Druid Hospital was transferred

The Memorial Institute in Llangefni's
High Street was built in 1906.

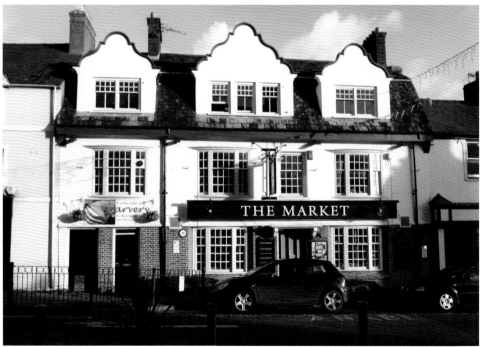

The Market Hotel, Llangefni, was built in the Arts and Crafts style early in the twentieth century.

to Cildwrn, Llangefni in temporary buildings and opened in March 1943. Later the Druid Hospital was used for geriatric care and was closed in the 1980s.

During the war a water scheme was developed for the town. Water from a local source was piped into two settling tanks in the Dingle. The water was then pumped up the opposite bank of the river to a reservoir and water tower (which was situated near the Pennant estate) from which Llangefni derived its tap water. The settling tanks and the pumping station, now redundant, can still be seen. The scheme became redundant when the Cefni Reservoir was completed in 1951.

In 1944 a new creamery was established in the southern outskirts of the town. It has continued to provide employment in the ownership of a number of companies, to the present day. Since 1992 it has been owned by Glanbia Ltd and produces cheese.

After the war, Llangefni embarked on an ambitious programme of housebuilding. Like many other areas, Llangefni erected prefabricated homes as a short-term means to alleviate a housing shortage. The Bron y Graig estate of prefabricated bungalows was built in the late 1940s. It was intended to have only a short life but it survived until the 1970s when the houses were demolished and replaced with other two-storey homes. Llangefni Council also built conventional housing such as the Maes Hyfryd estate shortly after the war. In fact, the immediate post-war period saw considerable housebuilding activity in Llangefni.

After the war, Llangefni was on the forefront of industrial development and the provision of jobs. A number of factories were established in Llangefni from the 1950s onwards, many being branch factories of companies located elsewhere. The names Warburton (established 1952), Cunliffe Gravure (1961), Wellman Controls (1965), Peboc (1973) and a number of others are still remembered in Llangefni as they provided much needed employment over a number of years. However, recent years have seen the closure of a number of these factories, but Llangefni's industrial estate (established in 1958) still provides employment for a number of the town's people with companies such as Two Sisters (formerly Vion) and Faun.

The town's emergence as a progressive authority was confirmed in the location of the National Eisteddfod in 1957 and subsequently in 1983. A new fire station opened in Lôn Newydd, Llangefni in 1959. It shares the premises with the Ambulance Service. The previous fire station was at the rear of the town hall.

Llangefni's earliest council houses were in the eastern part of the town, but in the early 1950s the Corn Hir and Pennant estates were built on the western outskirts. The large Pencraig estate in the eastern part of the town was also built in the 1950s following the sale of the Plas Pencraig estate. Council house building continued through the 1960s to the 1980s.

In the first two decades of the post-war period, comparatively few private housing developments were built and at one time Llangefni had more council homes than privately-owned homes. But as rate of council house building declined, the number of private housing developments increased, probably reflecting the increasing affluence of Anglesey society.

Llangefni was dealt a severe blow in 1964 when the Anglesey Central Railway was closed along with all its stations. The goods yard in Llangefni station became a car park. Although the line was used to transport materials to Amlwch's Octel works until 1993, it has lain idle since then although the track remains. There are still hopes that it could reopen in the future.

Llangefni had become the administrative centre for the County Council in 1895; in 1974, however, Local Government Reorganisation created the county of Gwynedd and this meant that the seat of local government moved to Caernarfon. Just over twenty years later, Ynys Môn again became a local authority and Llangefni resumed its role as county town. The new headquarters of the Anglesey County Council was built shortly after.

During the twentieth century, Llangefni had become an important shopping town and its central location had helped its success. After the Second World War, Llangefni still remained a vibrant shopping centre and most items could be purchased in Llangefni. In common with many small towns, a certain decline began in the 1980s and has continued over the past few decades. The development of larger shops in neighbouring towns made it difficult for some smaller shops to survive, and the face of Llangefni's shopping streets has changed considerably in this period. Llangefni suffered a massive blow when the cattle mart closed in 1997 and was transferred to Gaerwen. It was the tradition that farmers' wives came to Llangefni on mart days to do their shopping, but after the closure of the mart fewer people came to the town.

Notable features in the Llangefni area include Capel Cildwrn, the Grade 2 listed former Baptist chapel associated with Christmas Evans. It dates from 1782; Saint Cyngar's church situated near the River Cefni; the grade 2 listed Bull Hotel which dates from 1852; the grade 2 listed Town Hall which was built in 1884; and the Town Clock which dates from 1902.

Notable people connected with Llangefni include famous preacher Christmas Evans (1766–1838); the Revd John Elias (1774–1841); businessman Richard Davies (1774–1849); chapel minister and businessman the Revd James Donne (1822–1908); Thomas Charles Simpson (1894–1984) who was an accomplished actor and radio performer; folk singer and recording artist Gwen Price (1901–1972); artist Sir Kyffin Williams (1908–2006); Francis George Fisher (1909–1970), mathematics teacher, dramatist and one of the founders of Theatr Fach; solicitor and poet Roland Hugh Jones (1909–1963), also known as Rolant o Fôn; general practitioner Dr William Parry Jones (1897–1986) who served the town for decades; broadcaster and writer Hywel Gwynfryn (born 1942); Emyr Huws Jones (born 1950), musician and prolific songwriter; Tudur Morgan, guitarist, musician and songwriter; and Hollywood actress Naomi Watts (born 1968), who lived for a while in the area.

LLANGOED

Llangoed is a small coastal parish in the east of Anglesey. The main settlement in the parish is the village of Llangoed. The name Llangoed means 'the church in the trees'. The population is about 1,300.

Llangoed has been the economic and cultural centre of this area (including Penmon and Llan-faes) for well over 100 years. The village is in two parts – the lower part where the village hall was built and the more scattered upper part of the village near Saint Cawrdaf's church. There has been comparatively little modern development in the village.

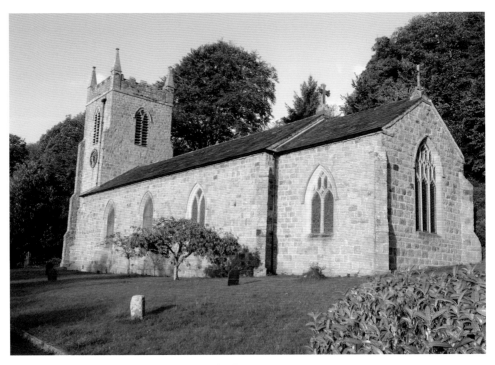

St Cyngar's parish church, Llangefni, was built in 1824.

The town hall, Llangefni, was built in 1884.

The town clock, Llangefni, built
in 1902. It is the only Boer
War memorial in Anglesey.

It was in the sea near Aberlleiniog in 1831 that the ship *Rothesay Castle* was shipwrecked after leaving Liverpool. A total of 130 passengers were lost and only twenty-three were saved.

Notable features in the area include Castell Aberlleiniog, the remains of an ancient castle, built in 1096; and Cornelyn Manor, built in 1841.

Notable people connected with the area include the Massey sisters, Edith Ellen Henrietta Massey (1863–1946) and Gwendoline Elizabeth Eveleen Massey (1864–1960) of Cornelyn Manor, who were accomplished artists; and broadcaster John Stevenson (born 1952).

LLANGRISTIOLUS

The name Llangristiolus means 'the church of Saint Cristiolus'. Llangristiolus is a fairly large parish with a comparatively small population; the main settlement is the village of Llangristiolus which is a very scattered community. Llangristiolus is close to Cors Ddyga (Malltraeth Marsh) where there is a history of coal mining.

A notable feature of the area is the mansion known as Henblas, originally built in 1581 but extended in 1626. Above the front door is a stone inscribed with the words: TANGNEFEDD I'R TŶ HWN, 1626 (Peace unto this house, 1626).

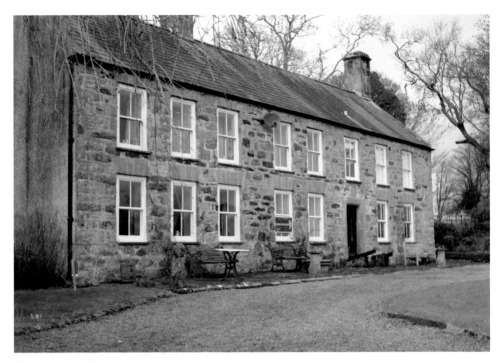

The mansion of Henblas, Llangristiolus.

Notable people associated with Llangristiolus include headteacher, local historian, author and broadcaster Thomas George Walker (1900–1984); musician, composer and glove maker David Hughes (1810–1881), often known as Cristiolus Môn; author, dramatist and actor Ifan Gruffydd (1896–1971); singer and songwriter Meinir Gwilym (born 1983); and singer Lucy Kelly (born 1998).

LLANGWYFAN

Llangwyfan is a small sparsely populated coastal parish in the south-west of Anglesey. The parish has no sizeable settlements.

The most notable feature of the parish is the island church of Saint Cwyfan. The present building was originally erected in the twelfth century on the mainland overlooking the sea. During the seventeenth century, rapid erosion of the land started to create an island; this island was complete by the beginning of the eighteenth century. The erosion was so severe that part of the church fell into the sea at the beginning of the nineteenth century. The church and the island were protected by a wall built towards the end of the nineteenth century by which time the church itself was a roofless ruin. However, the building was restored and still remains. Occasional services are still conducted here (tide permitting) in the summer.

The new church of Llangwyfan was built in 1871 when the old church became derelict. This church was built about a mile from the coast in a quiet rural location.

A notable person from Llangwyfan was the Reverend David Cwyfan Hughes (1886–1966). He was ordained in 1914 and was Minister at Bryn Du chapel for six years before coming to Capel Mawr, Amlwch. He was one of Anglesey's finest preachers.

Anglesey's only motor-racing circuit, Trac Môn, is in a coastal location in the parish. This is the site of the former Tŷ Croes army camp.

LLANNERCH-Y-MEDD

Llannerch-y-medd is a large village near the centre of the island. '*Llannerch*' means 'a glade' and '*medd*' means 'mead', which is a drink made from honey.

Shoemaking and clogmaking were industries that put Llannerch-y-medd firmly on the map. From the end of the eighteenth century, until the 1860s, Llannerch-y-medd had a very successful shoe-making industry. In its heyday, there were approximately 250 craftsmen working in this industry. Shoes were supplied for the miners at Mynydd Parys near Amlwch as well as for the slate quarrymen of Caernarfonshire. Llannerch-y-medd shoes were made of the best local leather and they would last for years. The village was sometimes known as 'Little Northampton'. The demand for the shoes declined due to the development of shoe production in Northampton. By the end of the nineteenth century, the shoe industry in Llannerch-y-medd was almost at an end.

There was also a time when ropes for use at Mynydd Parys were produced in Llannerch-y-medd. Clock-making was also undertaken in the village; the name Owen Owen is noteworthy in this context as he made grandfather clocks which can still be seen today in some homes around the island and beyond. During the nineteenth century, snuff was also produced in Llannerch-y-medd. It was known in Welsh as '*llwch mân Llannerch-y-medd*' (the fine dust of Llannerch-y-medd).

A printing and publishing industry flourished in Llannerch-y-medd during the nineteenth century. On account of its cultural and literary activity, Llannerch-y-medd became known as 'Athen Môn' (the Athens of Anglesey) as many of the village's residents were cultured people: poets, musicians, dramatists and actors.

Llannerch-y-medd workhouse was built around 1868 for seventy people. It is located north of the village on the Amlwch road. The workhouse cost approximately £2,000 to build; it was a two-storey building with a cruciform shape.

During the Second World War, there was a hostel for the Women's Land Army in Llannerch-y-medd. RAF Mona had a communications centre located on high ground at Pen y Foel, on the outskirts of the village. The roofless remains of one of the buildings can still be seen today, together with the base for a communications aerial. On 29 January 1944, an aircraft from RAF Mona crashed at Llannerch-y-medd. One member of the crew died but the other four survived.

Today, Llannerch-y-medd has fewer shops than it once had but it has public houses and a garage. The railway station closed in 1964. There has been comparatively little housing development in recent times and the village has retained its character. The population of the area is around 1,900.

The Square, Llannerch-y-medd.

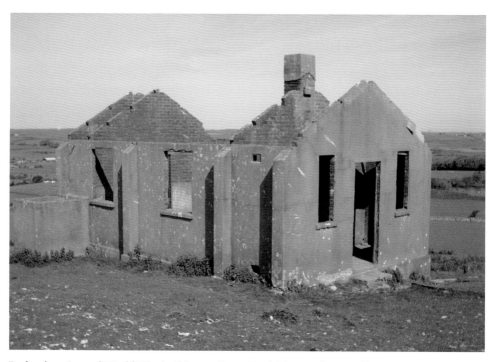

Redundant Second World War building at Pen-y-Foel, Llannerch-y-medd.

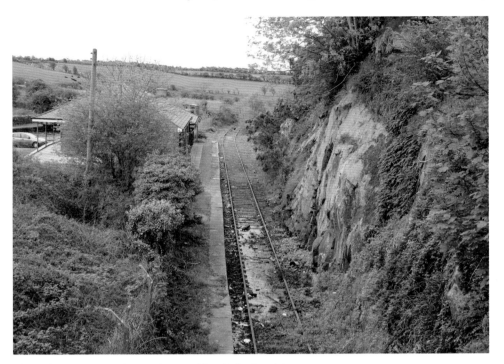

The railway station, Llannerch-y-medd, which closed in 1964.

A notable local feature is the mansion of Llwydiarth Fawr which was the home of William Jones (1840–1918) who had made a fortune in the building industry in Liverpool. It was here that William Jones, also known as 'Klondyke Bill' started a lucrative brickmaking business. Llwydiarth Fawr is now a guest house.

Notable people include poet and chapel minister Richard Parry (1803–1897) who was also known by his bardic name 'Gwalchmai'; poet and farmer William Charles Owen (1880–1973), also known as Llew Llwydiarth; musician and writer Owen Williams (1774–1839); and actor and dramatist John Huws (1913–1972) who ran the famous Llannerch-y-medd Drama Company.

LLANRHUDDLAD

Llanrhuddlad is a coastal parish in north-west Anglesey. The main settlement is the village of Llanrhuddlad. Llanrhuddlad (sometimes spelt Llanrhyddlad) means 'the church of Saint Rhuddlad'. Nearby is Porth Swtan ('bay of the whiting') where a brook called Afon Swtan flows into the sea.

Porth Swtan is the location of a cottage called Swtan, the only thatched roofed long house in Anglesey. The restoration of the cottage has been done in such a way that it resembles the cottage as it was in the early twentieth century.

LLANSADWRN

Llansadwrn is a rural parish in the east of Anglesey. Its largest settlement is the small village of Llansadwrn. Llansadwrn means 'the church of Saint Sadwrn'.

One of its most notable features is Hafoty, which is believed to be the oldest dwelling in Anglesey. It dates back to the fourteenth century, perhaps even earlier. Hafoty is an excellent example of what is generally known in Welsh as a *tŷ neuadd* (a hall house).

Ieuan Wyn Pritchard Roberts (1930–2013) was born in Llansadwrn where his father was Minister of Capel Penucheldref. He became well-known as a Conservative politician and represented the Conwy constituency for a number of years. After leaving the Commons, he became Lord Roberts of Conwy.

LLANTRISANT

Llantrisant is a large rural parish which is located south-east of Llanddeusant. Llantrisant means 'the church of three saints'. There are no large settlements in the parish.

Notable people connected with Llantrisant include fourteenth-century poet Gruffydd Grug; and David Hughes (*c.*1536–1609) who acquired wealth in Norfolk. He provided money for the establishment of a 'Free Grammar School' in Beaumaris and the school was founded in 1603.

MALLTRAETH

The name Malltraeth translates literally as 'dirty beach'. The village was originally known as Rhyd y Maen Du. '*Maen Du*' means 'black stone' and this probably referred to coal. Around 1860 a small coalfield was opened which provided coal for the Parys Mountain copper mines. The village was sometimes called Malltraeth Yard as it became a small port and shipbuilding yard. Malltraeth cob, built during the period 1788–1812, ensures that the sea cannot flow up the river Cefni. The Malltraeth estuary is well known for its bird life. The village has changed comparatively little in recent decades and still retains a shop, public houses, a chapel and a church.

The artist and illustrator Charles Tunnicliffe (1901–1979) lived in Malltraeth from 1947. He is well-known for his paintings of wildlife, particularly birds, which he observed from his house which overlooked the estuary. Many of his paintings are on display at Oriel Môn, near Llangefni.

The Malltraeth Estuary.

MARIANGLAS

The small village of Marianglas is in the parish of Llaneugrad, about two miles from Benllech. Marianglas has a large attractive village green which is an unusual feature in Anglesey.

The Parciau estate was once an important employer in the area. The mansion of Parciau was located behind the church of Llaneugrad and four lodges can still be seen.

The British submarine *Thetis* beached at nearby Traeth Bychan on 3 September 1939. While undergoing sea trials in Liverpool Bay with 103 people on board, the vessel sank and only four men survived. The submarine was later towed to Holyhead where there is a memorial in Maeshyfryd Cemetery.

Marianglas is well-known for its Eisteddfod which was established in 1924. For years it was held on St David's day but is now held in October every year.

Notable people associated with Marianglas include Oscar-winning actor Hugh Griffith (1912–1980) and his actress sister Elen Roger Jones (1908–2002); author, journalist and lecturer John Williams Hughes (1906–1977); the Revd John Phillips (1810–1867), who founded the Normal College, Bangor; the Revd Robert Williams, a schoolmaster, minister and poet; historian and translator T. Ceiriog Williams; historian and poet David Austin Williams; and harpist Llio Rhydderch.

MENAI BRIDGE

The town is situated in the south-east of Anglesey on the narrowest part of the Menai Straits. The town itself is very low-lying with the River Cadnant (which rises in Llanddona) entering the sea at Porth Cadnant on the outskirts of Menai Bridge between Ynys Gaint and Ynys Castell which are small islands east of the suspension bridge. Ynys Faelog is another small island east of the bridge. To the west of the bridge are Ynys Tysilio (Church Island) and Ynys Gorad Goch, which is an island in the Swellies between the two bridges. It has a fish trap and is only accessible by boat. The population of Menai Bridge is currently around 3,900 which is about the same size as Amlwch.

St Tysilio established a religious cell or small church on the island which now bears his name in the seventh century (AD 630) and this is the earliest record of the settlement. Since the settlement was situated at the narrowest point of the Straits, it became an important crossing point between Anglesey and the mainland. The original name for the town was Porthaethwy. 'Porth' is a port or harbour and 'Daethwy' is the name of the Celtic clan who once lived there. The name Menai Bridge dates from the 1820s when the suspension bridge was built.

There was a small collection of farms on the higher ground in the area in the Middle Ages. The area nearest the Straits was common land, known as Cerrig y Borth. The only building in this area was the old ferry house which was built in 1686 and is now in Cambria Street.

Anglesey was always a very fertile island and large numbers of cattle were reared for export to the rest of Wales and beyond. By the end of the eighteenth century, it is estimated that as many as 10,000 cattle crossed the Straits at Porthaethwy every year. A cattle fair on the mainland (near the Antelope Inn) was held from 1691 although this was later transferred to the Anglesey side. This developed into what is now known as Ffair y Borth (Menai Bridge Fair). Ffair y Borth continued well into the twentieth century as a cattle fair with fairground amusements and stalls. However, the site of the cattle mart was developed as a supermarket (originally called Leo's) and the animal sales became a thing of the past. Nowadays the fair is merely a large outdoor market with fairground rides held annually on 24 October.

Towards the end of the eighteenth century the Porthaethwy ferry developed in importance and became busier as it was perceived to be safer than some of the other ways of crossing the Straits. By 1801 the population of Porthaethwy was only 263.

A bridge to link Anglesey to the mainland had been considered in the 1770s. Ireland had entered the Union in 1801 and this made a link over the Menai Straits to Anglesey more important. John Rennie came to the area in 1801 and a bridge design was proposed but not built. Thomas Telford (1757–1834) was appointed to study the road system in north Wales including the provision of a bridge across the Menai Straits. Telford proposed a cast iron arched bridge but later produced a design for a suspension bridge (which allowed tall ships to pass under it) and this was approved in 1818. The bridge was built over the narrowest part of the channel. Work began

The High Street, Menai Bridge.

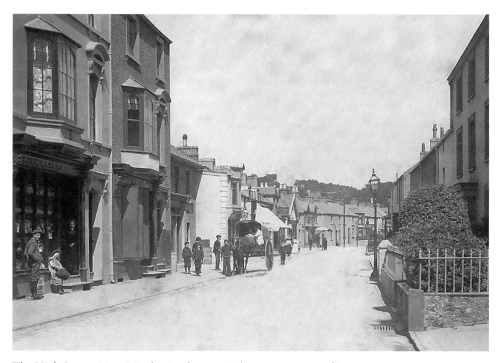

The High Street, Menai Bridge (early twentieth-century postcard).

St Tysilio's church, Menai Bridge, dates from the fourteenth and fifteenth centuries.

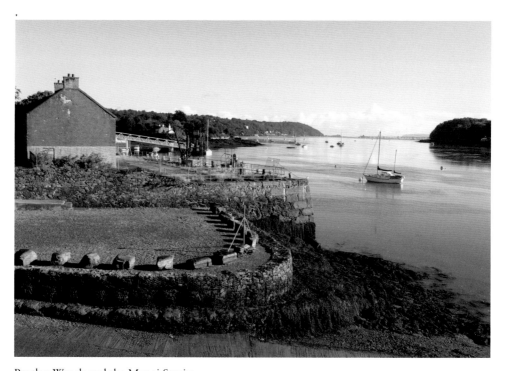

Porth y Wrach and the Menai Straits.

in 1819, the first chain was thrown across the straits on 15 April 1822 and it was opened on 30 January 1826.

The bridge has a clear span of 580 feet and the total road length is 1,265 feet. It is 100 feet above the water. On the opening day it was estimated that over 20,000 people walked over it. The total cost of the bridge was £120,000 and four men died during its construction. It gave rise to a period of rapid population growth in the area. In 1831 the population of the town had increased to 497; in 1841 it was 875 and in 1851 it had reached 1,243. Much of the street layout of the town dates from the nineteenth century and the architecture is predominantly Victorian.

When the Chester and Holyhead Railway began planning their railway in the 1840s, the government was in favour of trains running over Telford's bridge. However, Robert Stephenson (1803–1859) felt that the bridge would not be strong enough for this purpose and therefore a new bridge would be necessary. In 1850 Robert Stephenson's magnificent tubular railway bridge, about a mile from Telford's bridge, was completed. It took the form of two hollow tubes of wrought iron held by stone piers.

Since Stephenson's bridge was located about a mile from Menai Bridge, the railway line could not pass through the town. Although there was a Menai Bridge station from 1858 onwards, this was located on the mainland, not far from the Caernarfonshire end of Telford's bridge. However, Menai Bridge station closed to passengers in 1966 and it closed completely in 1968.

From the 1820s onwards, the town was beginning to develop as a place of recreation. In 1828, the St George Steam Packet Company was operating a ship named *Prince Llewelyn* from Liverpool to Menai Bridge. Two years later, *Mona's Isle* was being operated between Menai Bridge and the Isle of Man. Pleasure steamers of this type, operated by various companies, ran for decades and were perceived as a good source of income for the town's businesses. Names such as *St Tudno* and *St Seiriol* are still remembered by the town's older inhabitants.

In 1894 a tarmac surface was provided on some of the town's roads for the first time. In January 1895, the Menai Bridge Urban District Council was officially formed. In 1896 the Town Council decided to name the town's streets officially and name plates were erected. The Welsh names were not decided until 1970 and bilingual street signs were phased in over a five year period.

The town's old reservoir was near Tyddyn To but wells also supplemented the supply. However, the supply of water became a critical problem for an expanding town. In 1901, after a particularly dry summer, the reservoir was declared 'dry'. On account of a delay during the First World War, a new reservoir at Rhosnadredd (near Ysgol David Hughes) was not opened until 1923. However, by the 1940s the supply was again deemed insufficient and water was piped from Bangor over the Menai Bridge from September 1941. After the war, Menai Bridge was supplied by the Anglesey water scheme which ensured a plentiful supply from 1951 onwards.

Menai Bridge had been lit by gas since 1858 (when the Menai Bridge Gas and Coke Company Ltd was established) and by 1895 there were twenty-two gas lamps in the town, increasing to forty-six by 1904. The gas came from the local gas works; this company was taken over by the Holyhead Gas Company in 1896. But electricity was perceived as the way forward and in 1913 the installation of electric street lighting went ahead using electricity produced locally. Unfortunately, the Menai Bridge Electric Light Company was in financial difficulties by 1916 and the town council was being

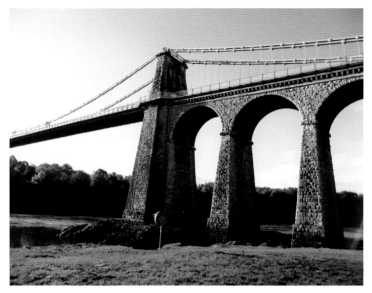

The Menai Suspension Bridge.

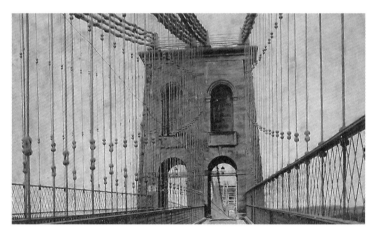

The Menai Suspension Bridge, around 1910, showing the suspension chains then in use.

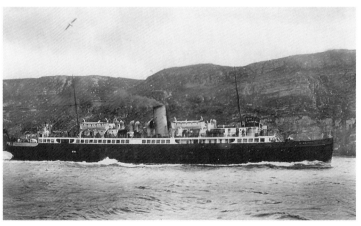

The steamer *St Seiriol* called frequently in Menai Bridge.

urged to take over the company. After initial reluctance to do so, it finally bought the company for £700 in 1922 and more street lights were installed. By 1934, the electricity grid supplied power to Menai Bridge and local production was halted.

At the beginning of the twentieth century, the new Urban District Council bought land near the pier for recreational purposes. The Council also purchased St George's Pier for £2,500 and after improvements it was reopened in 1904. There was a pavilion at the end of the pier. Both the refurbished St George's Pier and the Prince's Pier were regarded as crucial in the development plan that the Council envisaged.

As the result of the German invasion of Belgium in 1914, a substantial number of Belgian refugees arrived in Britain. A number of them stayed in Anglesey at various times between 1914 and 1916– mostly at Menai Bridge, but also at Beaumaris, Amlwch, Llangefni, Gwalchmai and Dwyran. Sixty-three refugees arrived in Menai Bridge in October 1914 and were welcomed by the town's brass band which played the Belgian national anthem. It was reported that three houses in Menai Bridge had been furnished for Belgian refugees and a fourth home was proposed in Nant Terrace.

It was suggested that work could be provided for the male Belgian refugees in the Menai Bridge area by improving the road on the shore from Carreg yr Halen to Church Island. Funding was secured from the Belgian Refugee Fund and the work was able to proceed.

In February 1916, it was reported that all the Belgian refugees had left Menai Bridge as they had found work in England. All the furniture and household effects in the houses they occupied in Nant Terrace (Cadnant Road) were to be sold. The 'Belgian promenade' which they helped to build is still a lasting reminder of their period in the town. The promenade was restored in 1965.

In August 1918 the Bishop of Bangor consecrated the whole of the island of Saint Tysilio in Menai Bridge for public burial. Previously only part of the island had been used for this purpose, the remainder being used for agriculture. The Marquess of Anglesey had conveyed the whole of the island to the church. Three days later, painting work on the Menai Suspension Bridge was completed. The work had taken three months.

In 1919 permission was given to erect sixteen houses on Gasworks Field; these houses were named Rhyd Menai and were built at a cost of £17,344. The Council stipulated that local labour should be used to build them. In 1930, twelve houses were built near Bryn Aethwy and named Bro Hyfryd (on Pentraeth Road, opposite the old primary school). In 1931, ten houses were built in New Street with bathrooms and hot water. Menai Bridge town itself had a number of slum dwellings in stark contrast to the area between the town and Beaumaris, popularly known as the 'Millionaire's Mile' which boasts a number of fine houses, including the recently-restored Plas Rhianfa.

A slum clearance scheme was started in 1933 with a total of thirty-two houses in Well Street, Wood Street, Dew Street and Dale Street being condemned. William Evans and Company of Pentraeth built houses (named Bron Fedw) in Mount Street in 1937 and further houses were built in Well Street by the same company. Plans for eighteen houses at Tyddyn To were shelved because of the Second World War.

In an age when entertainment was not as freely available as it is now, amateur drama companies were to be found in most of Anglesey's towns and villages. They were a popular pastime for many, both actors and audiences, for decades. One of the first companies in Anglesey was Cwmni'r Borth which was established in Menai Bridge in 1919.

The Belgian Promenade. The promenade was built by Belgian refugees in 1914–1915.

The suspension bridge began a period of reconstruction in 1939 with new road deck and new chains being fitted but the masonry was unchanged. Although the A5 was freed from tolls in 1895, the Menai suspension bridge charged a toll until 1940.

Before the start of the Second World War, Menai Bridge Council had already established an Air Raid Precautions (ARP) Committee, Fire Prevention Committee and an Evacuation Committee. Hundreds of schoolchildren, teachers and mothers with young children were evacuated to Menai Bridge but as in other areas they gradually left the area, preferring to face the blitz than live in a 'boring' area like Menai Bridge. An ARP Centre was established near the timber yard; sirens would alert residents of air raids.

The reconstruction of the Menai Suspension Bridge was complete on 1 January 1941 and was now toll-free. During the war the bridge (as well as the Britannia railway bridge) was routinely guarded by uniformed men and police, in case of saboteurs. The movement of vessels through the straits was strictly controlled and the area was patrolled by boats based at Fort Belan (near Dinas Dinlle, Caernarfonshire). Permission was needed by any vessel wishing to pass under the bridges. There were also secret contingency plans concerning the action that could be taken should either or both bridges be rendered unusable by enemy action. In addition to the military guard on the bridges, a policeman was on duty on the Suspension bridge during the day and two policemen at night. In April 1945, the Crosville Bus Company used double-decker buses to cross the bridge for the first time.

In April 1942 a hostel was opened for the Women's Land Army in Holyhead Road, Menai Bridge (on part of a tennis court near to the present day telephone exchange). Air-raid shelters were built in St George's Road, Askew Street and Chapel Street.

The Second World War cost the lives of twenty-two local men. Menai Bridge Council established a post-war development committee and some of its aims were the establishment of a central bus stop, more housing, car parks, playgrounds, developing the pier and promenade as a boost to tourism. Pleasure steamers had resumed calling in Menai Bridge after the war. Housing was seen as a priority but Menai Bridge failed to develop as a holiday resort after the war. The town could only boast a shingle beach near the Belgian Promenade; it lacked a sandy beach and other amenities which so many other resorts had. Consequently, the development of the pier and promenade never happened.

The building of homes, however, proceeded quickly. The first council houses at Cae Nicholas were completed in 1948 and the estate was named Trem Eryri. The first houses in Tyddyn To were ready by 1951. Private housing was also seen as important, and estates at Maes yr Hafod, Y Glyn and Cae Tros Lôn began to be built in the late 1950s and the 1960s.

Coed Cyrnol is named after a Colonel Henry Sandys who lived nearby in the mid-nineteenth century. A hoard of Roman coins was discovered there in 1978. It has been an area of pine trees for many years and was acquired by the Urban District Council for £300 in 1949 and officially reopened by Lady Megan Lloyd George in 1951 as part of the Festival of Britain celebrations. A Tourist Information Centre was established near Coed Cyrnol in the mid-1960s. The new cemetery (in Holyhead Road) was ready for use by 1956; the old cemetery on Church Island was almost full by this time.

The University College of North Wales, Bangor purchased land in Menai Bridge in 1965 for £7,000 in order to develop the Marine Science Department (now the School of Ocean Sciences). The research vessel Prince Madog has become a familiar sight moored at St George's Pier. The pier was declared unsafe in 1967 but after remedial work was reopened in 1969. Its renovation was finally completed in 1970. The Cricket Club, which had lacked a ground of its own for years, acquired its own field in 1968.

The A5 was upgraded and widened in Menai Bridge in the mid-1960s and two roundabouts were built – one near the Anglesey Arms Hotel and the other near the old primary school. The roundabout nearest the bridge necessitated the demolition of properties, including the Rock Vaults public house.

In 1969, Menai Bridge received a blow when the council was told that steamships would no longer be calling at Menai Bridge. The pleasure steamers had been in decline for some years, but this meant that a tradition spanning 140 years came to an end. It also marked the final end of Menai Bridge as a tourist resort. The Menai Bridge telephone exchange (in Holyhead Road) dates from the same year. It is interesting to note that Menai Bridge was the last place in Anglesey to have an automatic telephone exchange. Previously, all telephone calls to or from Menai Bridge had to made via an operator.

The Waun was converted to a car park in 1967 and another car park at the rear of the Bulkeley Arms Hotel was completed in 1970. Wood Street became the site of a YWCA hostel (now demolished and a private housing development in its place) and was further developed as a bus station, library and a new Town Council office in the 1970s after the demolition of the National School. A sewage treatment works was established at Llyn y Felin. By 1971 the population of Menai Bridge was 2,570.

In 1970 a fire was accidentally started in the Britannia Bridge by a group of boys and the tubes were rendered useless. The bridge was rebuilt but with the addition of a road deck.

St George's Pier, Menai Bridge, which is now used by the *Prince Madog*, the research vessel of Bangor University's Ocean Sciences Department.

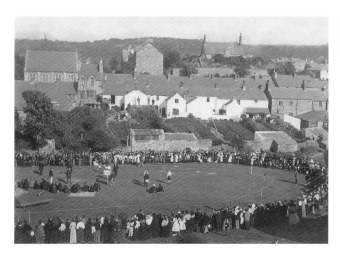

A sports event on the Waen Field, now a car park (early twentieth century).

The library and town council offices, Wood Street.

The Britannia Bridge with its new road deck (March 1981).

The Menai Bridge Urban District Council lasted from one local government reorganisation to another, from January 1895 to March 1974, when some of its responsibilities were taken over by the Anglesey District Council. However, Menai Bridge retains a Town Council but with fewer responsibilities.

A Welsh language community newspaper, *Papur Menai*, was established in 1976 to serve Menai Bridge and the surrounding villages. The paper is still published every month.

During recent decades, Menai Bridge has seen further changes. The Wesleyan chapel was demolished in 1978 and Council-owned flats now occupy the site. The closure of the old cattle mart near the bridge enabled the site to be developed as a supermarket, Leo's, later rebranded as the Co-op. The store is now operated by Waitrose; it is Menai Bridge's only supermarket. The town hosted the Urdd National Eisteddfod in 1976. The timber yard in Water Street has closed and some of the buildings used for private housing. The High Street has undergone substantial changes; few of the older shops have survived. Exceptions are Evans Brothers hardware store (established 1935), John Hughes' shop (established 1908) and the Grosvenor garage. A number of new businesses have sprung up in recent years, including several antique shops and eating houses. Only two banks now remain at Menai Bridge. Private housing developments have continued in the upper part of the town. Old People's flats were built on the corner of Wood Street and Dale Street on the site of the old Mona Products factory (which at one time employed over seventy people). The Tourist Information Office at Coed Cynrol has moved to the Pringle shop in Llanfair Pwllgwyngyll and various businesses have since occupied the Coed Cynrol premises.

Notable features in Menai Bridge include Saint Tysilio's church established around AD 630; Saint Mary's church, completed in 1858; the Anglesey Arms Hotel, built in 1830 and extended in 1896; the Victoria Hotel, completed in 1840; the Porthaethwy Ferry House, built in 1686; the former police station and court, built in 1845; and the hidden gardens of Plas Cadnant.

Two long-established businesses on Menai Bridge's High Street, the Hughes shop (established 1908) and Evans Brothers (established 1935).

The Anglesey Arms Hotel.

The Anglesey Arms Hotel, before its reconstruction (late nineteenth century).

St Mary's parish church, Menai
Bridge, was built in 1858.

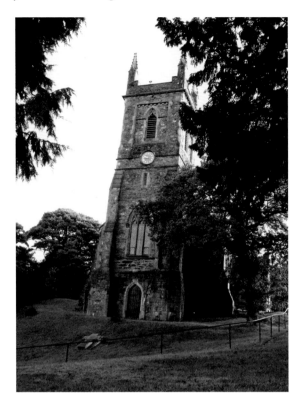

The Menai Bridge ferry house,
Cambria Road. It dates from 1686.

The former police station and court building dates from 1845.

Notable people connected with Menai Bridge include Richard Davies (1778–1849) who established a timber business in 1828 which was run by his family for decades before it ended in 1905; John Evans (also known as 'Y Bardd Cocos') (1827–1895) who was known for his eccentricity and the dire quality of his poetry; Sir J. E. Lloyd (a professor of history); the Revd Thomas Charles Williams (1868–1927), minister of Menai Bridge's Welsh Presbyterian chapel; the Reverend Edward Tegla Davies (1880–1967), minister of the Wesleyan chapel at Menai Bridge and popular author; linguist, teacher and missionary Dr Helen Rowlands (1891–1955); dramatist, lecturer and preacher the Reverend Sir Albert Evans Jones (1895–1970), usually known by his bardic name, Cynan; and cricketer Matthew Maynard (born 1966).

MOELFRE

The name Moelfre means 'a bare hill'. It is a fairly large picturesque village on the east coast of Anglesey in the parish of Llanallgo. The population is around 1,100. It has a rich maritime history and has produced large numbers of sailors and ships' captains. It is also well-known for its lifeboat which has taken part in a number of high profile rescues.

Moelfre once had a thriving fishing industry with herring being a major catch. Before the Second World War, great emphasis was placed on herring fishing and such was the success of this venture that the herrings were distributed throughout Anglesey and as far away as the big markets in England.

The village became famous for the shipwreck of the *Royal Charter* in 1859. On the 26 October the *Royal Charter* was making its way home from a trip to Australia and it was laden heavily with gold and when the weather took a turn for the worst, the ship was forced onto the rocks at Porth Helaeth. At least 450 lives were lost during this terrible tragedy. Moelfre found itself the focus of attention and the famous author Charles Dickens visited the site after the tragedy struck. As the result of this visit

Moelfre Beach.

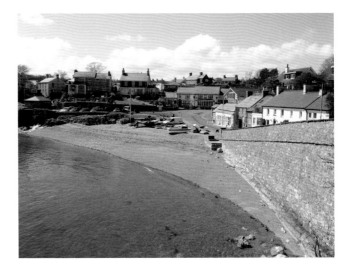

Moelfre on a stormy day (early twentieth century postcard).

he wrote an account in his book, *The Uncommercial Traveller*. The Rector of Saint Gallgo's church, Stephen Roose-Hughes, was kept especially busy during the tragedy with the sorry process of identifying the dead. He wrote a considerable number of letters to the relatives of the dead passengers. Many of the dead were buried at the churchyard in Llanallgo and there is a memorial to them there.

From the 1960s the population of the village increased significantly due to the building of some new housing estates. The seafaring tradition is no longer dominant and Moelfre produces few sailors today. The village continues to attract tourists and there are many holiday homes in the village.

The Seawatch Centre was opened in the 1990s; it houses a shop and exhibition as well as a real lifeboat. In 2013 the lifeboat station acquired a new lifeboat called the *Kiwi*, which has been bequeathed to the RNLI by a New Zealander.

Notable features in the area include the *Royal Charter* memorial on the clifftop overlooking the scene of the shipwreck; and the new lifeboat station, completed in 2015.

The old lifeboat station, Moelfre, was built in 1909. It was replaced by a new larger building in 2015.

Notable people connected with Moelfre include Richard Evans (1905–2001), better known as Dic Evans, who was associated with the Moelfre Lifeboat for many decades; sailor Thomas Lewis (also known as Twm Pen Stryd) who became famous as the survivor of a shipwreck; William Roberts (1881–1956), a colourful character who was awarded the VC in 1927; and Captain John Roberts who was awarded the DSO during the First World War.

NEWBOROUGH

This area, which was the location of one of the courts of the Welsh princes, was originally called Rhosyr. Following Edward I's expulsion of residents from Llan-faes it became known as the 'Newborough'. In Welsh, it is known as *Niwbwrch*. Although Newborough had been very important in the days of the Welsh princes, its importance later declined. Today Newborough is a fairly quiet rural village with comparatively few amenities.

In the past, significant local industries included the manufacture of mats, baskets and ropes. The marram grass which grew on the extensive sand dunes was harvested in order to make mats. The production of the mats was considered women's work and was carried out at home to supplement a family's income. The skills involved were passed on from mother to daughter. However, by the late 1930s demand for the Newborough mats had declined sharply. As a result, these skills stopped being passed from one generation to the next, and only a few women now possess these traditional skills and mat-making has long ceased on a commercial scale.

Due to its proximity to Newborough Warren (*Cwningar Niwbwrch*) the villagers used to catch rabbits which were sold as far away as England. Many locals also ate rabbit meat and home-made rabbit broths. With the onset of myxamatosis in 1954 the number of rabbits declined and this particular cottage industry ended.

Although the village of Newborough is located in a very rural location, its proximity to the sea meant that there was a strong seafaring tradition. At the turn of the twentieth century numerous ships' Captains lived in the village.

Corsican pines and other conifers were planted in Newborough Warren in 1948 to prevent sand being blown onto the roads. Today, Newborough Warren is a nature reserve. There are trails which cross the forest and the warren which are very popular with nature lovers and bird watchers. The area has a population of about 2,100.

About a mile south of Newborough is an area known as Llanddwyn. Llanddwyn (which means 'the church of Saint Dwynwen') is an island at high tide, but it is possible to walk over to it from Llanddwyn beach at other times. It is noted for its seabirds, such as shags, oystercatchers and cormorants. There are also some unusual rocks, such as pillow lavas, formed by undersea eruptions.

The church on Llanddwyn Island was established during the fifth or sixth century by Saint Dwynwen, daughter of King Brychan of Brycheiniog. By the fifteenth century, this abbey church was one of the richest in Anglesey and was a frequent place of pilgrimage. The remains of the church still stand and they underwent some restoration in 2012.

Notable features on the island include a Latin cross; a Celtic cross; and Pilots' Cottages which housed the pilots who were stationed at Llanddwyn to guide vessels through the Straits; and the lighthouse towers.

Among the area's notable features are Llys Rhosyr where a 1992 excavation unearthed one of the courts of the Welsh princes; the Prichard-Jones Institute which was completed in 1905; Newborough Forest which has a number of paths open to the public and Llanddwyn Island.

Notable people connected with Newborough include teacher, historian and poet Robert Williamson (1807–1852); historian and author Hugh Owen (1880–1953); businessman and philanthropist John Prichard Jones (1841–1917) who endowed Newborough with the Grade II listed institute which bears his name; novelist Jane Edwards (born 1938); and actor and scriptwriter John Pierce Jones (born 1946).

PENMON

Penmon is a sparsely populated parish on the eastern tip of Anglesey. The name translates as 'extremity of Anglesey'. It is known that the Vikings attacked Penmon in AD 971. Limestone from Penmon was used when Beaumaris castle was being built. Both Thomas Telford and Robert Stephenson also used Penmon stone for their bridges during their construction in the nineteenth century.

Notable features include the Dovecote, built by one of the Bulkeley family around 1600; the Trwyn Du Lighthouse, built in 1837; and Saint Seiriol's church.

The Prichard-Jones
Institute, Newborough.

St Seiriol's church and
dovecote, Penmon.

PENMYNYDD

Penmynydd is a large parish in south-east Anglesey. The main settlement is a small village, also called Penmynydd. In English, *Penmynydd* means 'top of the mountain'; there is a panoramic view from the highest part of the village where a great deal of the island can be seen on a clear day. It is a very scattered village with many of the homes being on either side of the B4520 which runs from Menai Bridge to Llangefni.

Notable features of Penmynydd include the Almshouses which date from the seventeenth century; the mansion of Plas Penmynydd which is associated with the Tudors; Sarn Fraint, which was once a coaching inn on the post road when it passed through Penmynydd.

The most notable family in the area were the Tudors. Owain ap Tudur married Katherine de Valois in 1429. Their grandson became Henry VII, the first Tudor king, in 1485. Thus the Tudor monarchs can trace their ancestry back to the Tudor family of Penmynydd.

PENTRAETH

Pentraeth is a village and coastal parish in the eastern Anglesey. The name Pentraeth means 'the extremity of the beach'. Pentraeth is near the wide expanse of sand known as Traeth Coch, or Red Wharf Bay, with the hilly region of Mynydd Llwydiarth nearby. Older names for Pentraeth were Betws Geraint or Llanfair Betws Geraint. Pentraeth lies on the banks of the River Nodwydd.

When the nineteenth-century traveller George Borrow visited Pentraeth in the summer of 1854 on his way to see the birthplace of Goronwy Owen, he described the village as occupying 'two sides of a romantic dell' and consisting of 'a few houses and a church'. By the beginning of the twentieth century, Pentraeth had become a busy village and served as an important centre for the surrounding rural areas.

The White Horse Inn was the name of the public house in Pentraeth where George Borrow stayed during his trip to Anglesey in 1854. This building is opposite the church but it ceased to be a tavern over 100 years ago. The Panton Arms is the tavern where Charles Dickens stayed on his way to see the wreck of the *Royal Charter*. It is named after the Panton family of Plas Gwyn. This public house is still open today.

Pentraeth railway station was opened in July 1908 in a fairly exposed location around a quarter of a mile from the centre of the village. There were facilities to

Traeth Coch (Red Wharf Bay) with Mynydd Llwydiarth in the distance.

handle coal and other goods. In 1930 regular passenger services were withdrawn on the Benllech railway line. In 1950 all traffic stopped and all the stations closed completely.

The Annual Village Show was held in the 1950s and 1960s on the fields behind the square. It was a much smaller version of the Anglesey Agricultural Show today.

At the end of the 1950s, a road improvement scheme was proposed for Pentraeth. This included remodelling the square, demolishing some buildings and constructing a new road towards the north so that the A5025 traffic did not pass along Chapel Street. The Old Bull's Head public house in Chapel Street closed in 1959 and the new Bull's Head is situated at the northern edge of the village. The improvement work on the village square necessitated taking land from the churchyard and this meant that a number of burials had to be exhumed and reburied at the far end of the churchyard. This inevitably resulted in great distress for a number of families.

From the late 1960s, the Betws Geraint and Hendre Hywel council estates were built in the village. In the 1970s a number of private houses were built at Nant y Felin. These developments increased the population of the village considerably. Today, a number of businesses are still located on the square and the village remains a lively community. There is an industrial estate and a garden centre on the northern outskirts of the village.

Notable features include the eighteenth-century mansion of Plas Gwyn, the Panton Arms public house originally built around 1750 and Saint Mary's church.

Notable people include entrepreneur William Williams (1834–1915) who owned property in Liverpool; farmer and stonemason William Lewis (1860–1929) who wrote an account of the places and people in the Mynydd Llwydiarth and Pentraeth area during his lifetime; opera singer and society photographer Ifor Owain Thomas (1892–1952); Mary Owen (1803–1911) who was the oldest inhabitant in Pentraeth; and local doctor and literary man John Roose Elias (1819–1881).

PENTRE BERW

The village stands on the A5 road very close to Gaerwen; it is sometimes referred to as Holland Arms, but is officially known by its Welsh name Pentre Berw (meaning 'village of the water cress').

The Holland Arms Hotel has been named after the Holland family who lived in the mansion of Plas Berw. Plas Berw dates from around 1480 but with later additions. Today, Pentre Berw is perhaps most noted for its long established garden centre.

PENYSARN

The name includes the elements '*pen*' (the end or extremity) and '*sarn*' (roadway raised above surrounding land). The village was once noted for clog-making, mostly

The Panton Arms, Pentraeth.

St Mary's parish church, Pentraeth.

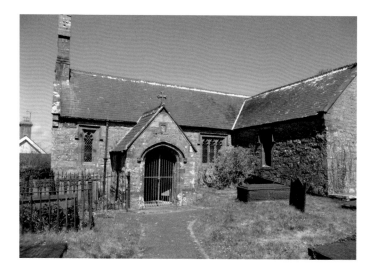

for the mineworkers of nearby Mynydd Parys. Locally, the name is often pronounced 'Pensarn'. Today, Penysarn is a small village but it has a shop, post office and school.

A notable feature in the area is the church of Saint Gwenllwyfo which is in a fairly isolated spot near Dulas Bay. It was completed in 1856. The church is especially noteworthy because it contains a number of impressive Flemish stained-glass panels dating from the fifteenth and sixteenth centuries. These were presented to the church in 1876 from the collection of Sir Thomas Arundell Neave.

Notable people connected with the area include poet, singer, novelist and journalist Lewis William Lewis (1831–1901), often known by his bardic name Llew Llwyfo; Presbyterian minister the Revd Simon Fraser (1836–1895); poet, journalist, politician and broadcaster John Eilian Jones (1904–1985); farmer and actor Glyn Williams; Bedwyr Lewis Jones (1933–1992), professor of Welsh at Bangor University; and actor Yoland Williams.

St Gwenllwyfo's church, Llanwenllwyfo, was built in 1856.

PORTH LLECHOG

Porth Llechog is a short distance west of Amlwch. The name Porth Llechog means 'bay of the township of Llechog'. The English name Bull Bay derives from a pool on the beach called *Pwll y Tarw* (the bull's pool). In the early nineteenth century Porth Llechog was a thriving shipbuilding and fishing port. Today, it is a residential area with some facilities for tourists.

RHOSCOLYN

Rhoscolyn means 'the moor of Colyn'. Colyn is a personal name. Rhoscolyn is a small agricultural hamlet in the south of Ynys Cybi (Holy Island). Its former name was Llanwenfaen, the church being dedicated to Saint Gwenfaen. There are houses and cottages in the village dating from Elizabethan times or even earlier and a few of these houses are Welsh long houses. Rhoscolyn was once renowned for oyster fishing and local marble was sent far and wide and used in building cathedrals in Bristol, Peterborough and Worcester. Rhoscolyn marble is also found in Saint Cybi's church, Holyhead.

Porth Llechog
(or Bull Bay).

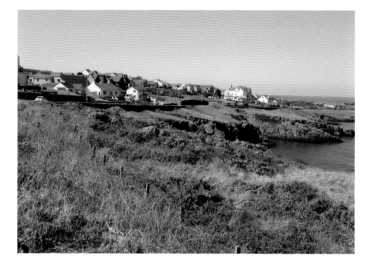

An interesting local story is that of Tyger, the dog who saved the entire crew of a ketch that was shipwrecked on nearby rocks. Sadly, the dog died of exhaustion in his master's arms. There is a memorial to commemorate him which reads 'Tyger, Sep 17th 1819'.

RHOSMEIRCH

The name Rhosmeirch translates as 'the moor of the stallions', suggesting that wild horses might have roamed the area at one time. The village lies on comparatively high ground about a mile from the centre of Llangefni and enjoys good views of Anglesey and the mountains of Snowdonia.

Oriel Ynys Môn was opened in 1991. It is a centre for the cultural life of Anglesey. It houses galleries which display works by Kyffin Williams (1918–2006), Charles Tunnicliffe (1901–1979) and the Massey sisters of Cornelyn Manor, Llangoed, as well as exhibitions by local artists. The centre also houses a shop for local crafts and books and a café. In the history gallery, there are artefacts from the *Royal Charter* disaster.

RHOSNEIGR

Rhos means moor and *neigr* refers to a person called Neigr. There was a thriving shipbuilding industry in Rhosneigr as far back as 1787 located on the shores of Llyn Maelog. The coast around Rhosneigr was notorious for shipwrecks. The 'Crigyll wreckers' of the eighteenth century would lure ships onto the rocks and plunder their wares. They were tried in Beaumaris in 1741 and executed. Rhosneigr has been a tourist area for well over a hundred years. Tourists continue to flock to its sandy

beaches and the area has a high proportion of holiday accommodation. Today, the population is just over 1,000.

A notable feature is Llyn Maelog which is well-known for its bird life, in particular the Great Crested Grebe, little Grebes and a variety of ducks.

RHOSYBOL

Rhosybol means 'undulating moor'. Rhosybol is a long village situated on the B5111 between Amlwch and Llannerch-y-medd. Rhosybol has changed comparatively little in recent times but it has lost a number of amenities.

TALWRN

Talwrn is a small village in the parish of Llanddyfnan. It is within a short distance of Llangefni. The name *Talwrn* means a cockpit or threshing floor. The name derives from a large area of rough heathland and marshland known as Talwrn Mawr; this name gradually became the name of the village and locality. Towards the end of the nineteenth century, the name became simply Talwrn.

Talwrn Mawr was an area of common land which was used for grazing and obtaining peat for burning. In the sixteenth and seventeenth centuries, every able-bodied man in Anglesey had to receive military training and Talwrn Mawr was used for musters. The Enclosure Act of 1812 authorised the closure of the common of Talwrn Mawr and the division of the land between local landowners.

By the beginning of the nineteenth century, houses were being built on the edge of Talwrn Mawr. By the end of the century, a small community had formed with a post office, four shops a public house, a smithy, a school, a village church and two chapels. There were also many craftsmen in the village – carpenters, stonemasons, slaters and cobblers and a furniture maker.

There is a war memorial on the square to commemorate those who died during the First and Second World Wars. The Talwrn Children's Choir achieved considerable fame during the Second World War. Founded and conducted by schoolmaster Cecil Jones, they performed all over Britain and raised thousands of pounds for charities. In November 1945, the Choir made a recording which was broadcast to the USA.

It was after the Second World War that essential services came to Talwrn. Mains water reached Talwrn in 1956 and electricity some two years later. A sewerage system was not built until 1975. Today, Talwrn remains a small pleasant village with limited amenities.

Notable people connected with Talwrn include John Jones (1885–1963), also known as Dyfnan, who was associated with amateur drama; poet and author Percy Hughes (1898–1962); artist, designer, architect and inventor Richard Huws (1902–1980); and Bethan Wyn Jones who is a regular broadcaster on aspects of nature and wildlife.

The Square, Rhosneigr.

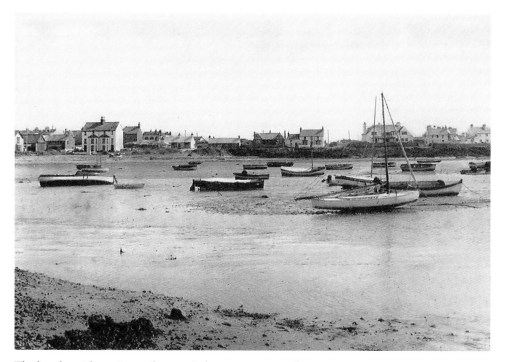

The beach at Rhosneigr, early twentieth-century postcard.

TREARDDUR

The settlement was once called Tywyn y Capel and the bay was called Porth y Capel. The name Trearddur derives from the personal name Iarddur, a notable medieval figure. Trearddur simply means 'the township of Iarddur'. The village is often called Trearddur Bay. The addition of the word 'Bay' coincides with the development of the area as a tourist resort which happened towards the end of the nineteenth century and early twentieth century.

Today, Trearddur is still a popular seaside resort with a high proportion of holiday accommodation; the beach is a European Blue Flag winner. The RNLI operate two inshore lifeboats from the local lifeboat station. The population is around 1,900. The village has a number of shops and a garage.

VALLEY

Valley is a fairly large village in western Anglesey, close to Holyhead. The name Valley dates from the period when Telford's post road was being constructed in the 1820s. The village grew around this road and later around the railway from the middle of the nineteenth century.

During the Second World War, there was a hostel for the Women's Land Army at Valley. The name Valley is used by the RAF airbase which was established during the Second World War. Today, Valley is a thriving village with a number of shops, hotels and garages. There have been a number of housing developments in recent decades. The population of the area is around 2,500.

BIBLIOGRAPHY

Anthony, Herbert, *Menai Bridge and its Council* (Menai Bridge: Menai Bridge Council, 1974)

Benwell, Ann, *Stori'r Talwrn / The Story of Talwrn* (Talwrn: Talwrn Archaelogy Group, 2000)

Borrow, George *Wild Wales* (London: Collins, 1969)

Bradbury, Margaret, *Memories of Pentraeth and its People 1900–1970* (Pentraeth: published by the author, 2012)

Davies, John, *O Fôn i Fynwy* (Cardiff: Gwasg Prifysgol Cymru, 1973)

Evans, Robin, *Moelfre a'r Môr* (Llanrwst: Gwasg Carreg Gwalch, 2009)

Gruffydd, Ifan, *Gŵr o Baradwys* (Denbigh: Gwasg Gee, 1963)

Hughes, Margaret, *Anglesey Sketches* (Llanrwst: Gwasg Carreg Gwalch, 1999)

Hughes, Margaret, *Anglesey Remenbers Some of Its Eminent People* (Llanrwst: Gwasg Carreg Gwalch, 2000)

Hughes, Margaret, *Anglesey 1900* (Llanrwst: Gwasg Carreg Gwalch, 2002)

Hughes, Margaret, *The A-Z of Anglesey* (Llanrwst: Gwasg Carreg Gwalch, 2005)

Jones, Dafydd Glyn, *Un o Wŷr y Medra* (Denbigh: Gwasg Gee, 1999)

Jones, Dewi and Thomas, Glyndwr (editors), *Nabod Môn* (Llanrwst: Gwasg Carreg Gwalch, 2003)

Jones, Geraint I. L., *Anglesey Railways* (Llanrwst: Gwasg Carreg Gwalch, 2005)

Jones, Geraint I. L., *Anglesey Churches* (Llanrwst: Gwasg Carreg Gwalch, 2006)

Jones, Geraint I. L., *Capeli Môn* (Llanrwst: Gwasg Carreg Gwalch, 2007)

Jones, Geraint I. L., *Anglesey at War* (Stroud: The History Press, 2012)

Jones, Gwilym T. and Roberts, Tomos, *Enwau Lleoedd Môn* (Bangor: Research Centre Wales, Bangor University, 1996)

Lewis, K. E., *Môr a Mynydd* Sarah E. Williams (Ed.) (Llanfairpwll Gwyngyll: published by the editor, 1983)

Lewis, Samuel, *Topographical Dictionary of Wales* (1833)

Lewis, William, *Cipdrem yn Ôl* (Pentraeth: published by the author, 1926)

Owen, Hywel Wyn and Morgan, Richard, *Dictionary of the Place-names of Wales* (Llandysul: Gwasg Gomer, 2007)

Pretty, David A., *Anglesey: The Concise History* (Cardiff: University of Wales Press, 2005)

Pretty, David A., *Two Centuries of Anglesey Schools* (Llangefni: Anglesey Antquarian Society, 1977)

Richards, Melville (ed.), *Atlas Môn* (Llangefni: Cyngor Gwlad Môn, 1972)

Roberts, Dewi, *An Anglesey Anthology* (Llanrwst: Gwasg Carreg Gwalch, 1999)

Roberts, W. Arvon, *Lloffion Môn* (Llanrwst: Gwasg Carreg Gwalch, 2011)

Rowlinson, Gwenllian J., *Golwg ar Rai o Blastai Môn* (Llanfair Pwllgwyngyll: published by the author, 2011)

Simpson, Thomas Charles, *Cnoc ar y Drws* (Caernarfon: Llyfrfa'r Methodistiaid Calfinaidd, 1968)

Thomas, Nigel and Jones, Carol (Eds), *Hanes Llanfechell* (Llanfechell: Menter Mechell, 2011)

Walker, T. G., *Dau Blwyf, Llangristiolus a Cherrigceinwen* (Llangristiolus: published by the author, 1944)

Williams, Elizabeth A. *Hanes Môn yn ystod y Bedwaredd Ganrif ar Bymtheg* (Amlwch: Cymdeithas Eisteddfod Gadeiriol Môn, 1927)

Williams, O. Arthur, *Hanes y Ddrama Gymraeg ym Môn 1930–1975* (Caernarfon: Gwasg y Bwthyn, 2008)

A number of editions of the *Anglesey Antiquarian Society Transactions* and various websites, leaflets, newspapers and journals were also consulted.